WHAT HOLDS US TOGETHER

PSYCHOANALYSIS AND POPULAR CULTURE SERIES

Series Editors: Caroline Bainbridge and Candida Yates

Consulting Editor: Brett Kahr

WHAT HOLDS US TOGETHER

Popular Culture and Social Cohesion

Barry Richards

with contributions by
Joanne Brown and Karl Figlio

KARNAC

First published in 2018 by
Karnac Books Ltd
118 Finchley Road, London NW3 5HT

British Library Cataloguing in Publication Data

A C.I.P. for this book is available from the British Library

 ISBN 978 1 78220 123 6

Edited, designed and produced by The Studio Publishing Services Ltd
www.publishingservicesuk.co.uk
email: studio@publishingservicesuk.co.uk

Printed in Great Britain

www.karnacbooks.com

CONTENTS

CHAPTER FIVE

ABOUT THE AUTHOR

Barry Richards is Professor of Political Psychology in the Faculty of Media and Communication at Bournemouth University. Prior to moving to Bournemouth in 2001, he was Professor and Head of the Department of Human Relations at the University of East London. His books include *Images of Freud: Cultural Responses to Psychoanalysis* (Dent, 1989), *Disciplines of Delight: The Psychoanalysis of Popular Culture* (1994), *The Dynamics of Advertising* (with I. MacRury & J. Botterill, Harwood, 2000), and *Emotional Governance: Politics, Media and Terror* (Palgrave, 2007). He was a founding co-editor of the Sage journal, *Media, War and Conflict*, and of the independent journal *Free Associations*, and was first convenor of the "Psychoanalysis and the Public Sphere" conferences, held annually in London from 1987 to 2000. He has written widely on popular culture and politics; his major interests are in the psychology of politics, particularly in the emotional dynamics of conflict, extremism, and nationalism, and in psychosocial dimensions of cultural change.

The application of psychoanalytic ideas and theories to culture has a long tradition and this is especially the case with cultural artefacts that might be considered "classical" in some way. For Sigmund Freud, the works of William Shakespeare and Johann Wolfgang von Goethe were as instrumental as those of culturally renowned poets and philosophers of classical civilisation in helping to formulate the key ideas underpinning psychoanalysis as a psychological method. In the academic fields of the humanities and social sciences, the application of psychoanalysis as a means of illuminating the complexities of identity and subjectivity is now well established. However, despite these developments, there is relatively little work that attempts to grapple with popular culture in its manifold forms, some of which, nevertheless, reveal important insights into the vicissitudes of the human condition.

The "Psychoanalysis and Popular Culture" book series builds on the work done since 2009 by the Media and the Inner World research network, which was generously funded by the UK's Arts and Humanities Research Council. It aims to offer spaces to consider the relationship between psychoanalysis in all its forms and popular culture that is ever more emotionalised in the contemporary age.

In contrast to many scholarly applications of psychoanalysis, which often focus solely on "textual analysis", this series sets out to

explore the creative tension of thinking about cultural experience and its processes with attention to observations from the clinical and scholarly fields of observation. What can academic studies drawing on psychoanalysis learn from the clinical perspective and how might the critical insights afforded by scholarly work cast new light on clinical experience? The series provides space for a dialogue between these different groups with a view to creating fresh perspectives on the values and pitfalls of a psychoanalytic approach to ideas of selfhood, society, and popular culture. In particular, the series strives to develop a psycho-cultural approach to such questions by drawing attention to the usefulness of post-Freudian and object relations perspectives for examining the importance of emotional relationships and experience.

What Holds Us Together: Popular Culture and Social Cohesion contributes to the work of the series by drawing on object relations psychoanalysis to examine the feelings that both bond and divide us in different social, political, and cultural contexts. Barry Richards has been at the forefront in pioneering such an approach—one that takes account of the complex interweaving of psychological, social, and cultural experience. In this book, he both revisits and develops his earlier work on these themes and, in so doing, he foregrounds the idea that popular culture is popular because it is "containing". The notion of containment, in this context, resonates with the work of Wilfred Bion and is used by Richards to explore the use that is made of popular activities from the spheres of sport, music, consumer culture, and politics in order to manage anxiety in an uncertain world. As a renowned scholar in the psychosocial field of political psychology, Richards draws on that work here to bring original insights to bear on the experience of nationalism as a cultural force which can potentially be used in a positive way to shore up a shared sense of large-group identity, providing a "psychic home" in an era where an experience of belonging is often sought after, yet undermined by forces seemingly beyond one's control. In celebrating a new vision of the popular and its role in public life, Richards provides us with a nuanced and hopeful vision of what popular culture and politics can offer by way of social cohesion and also the conscious and unconscious ties that hold us together.

Caroline Bainbridge and Candida Yates
Series Editors

PREFACE

We are all, in some senses, held together by the societies and cultures in which we live—held together as functioning communities, and as functioning individuals. How does this process of containment work? What is it that keeps us, collectively and individually, from falling apart? Psychologically, we have powerful but complex needs for security and pleasure, and we must contend with destructive impulses in ourselves and others. To varying degrees, our social worlds provide us with opportunities for meeting those needs and managing those impulses, in ways that maximise our fulfilment as individuals while reaffirming our commitment to the collective entities of which we are a part, and on which we depend. Thus, the societal environment can serve, however imperfectly, as a containing matrix for the individual psyche.

In the twentieth century, popular culture came to the fore in the Western world as the most important area of everyday life in which experiences of this sort were available, experiences that combine expression and release with ultimate acceptance of the need for restraint essential for any human community to exist. Popular culture, most dramatically in the areas of sport, music, and aspects of consumer culture, combines intense pleasures with submission to the

authority of the societal "other". As such, it reconciles the individual to the constraints of societal membership, and in so doing helps to keep society cohesive and the individual sane.

Towards the end of the twentieth century, this reconciliatory and containing power of popular culture was strengthened by the rise within it of greater interest in emotional life and the emergence of what can be called 'therapeutic culture'. While this is a mixed development, the self-reflection it promotes can offer individuals deeper and more authentic participation in cultural practices. It also facilitates integration of different parts of the self, reducing the rigid compartmentalisation which is characteristic of the modern psyche as anatomised by Freud. This process of compression or fusion of different areas of psychic life is also driven by the broad trend towards cultural liberalisation, seen especially in the sexualisation of everyday life which is driven mainly by consumer culture. The therapeutic orientation brings moral sensibilities to what otherwise might have been a more antisocial hedonism. Libido and superego can live together more easily and speak more freely to each other.

However, this complex but basically positive development in global culture intensifies major problems in the political sphere. While popular culture is increasingly able to engage and satisfy us emotionally, democratic politics is becoming an object of indifference or repugnance to growing numbers of citizens. While partly based in the shortcomings of political leadership and the corrosive cynicism of the media, this crisis of legitimacy reflects a gathering shift away from experiencing the liberal democratic state as a source of emotional containment, and towards popular culture as the primary source of collective identities and shared meanings. Drained of emotionally compelling appeal at its centre, the democratic polity becomes more vulnerable to colonisation by regressive and potentially violent extremisms and fundamentalism. Under pressure also from widening marketisation and privatisation, the state ceases to fulfil its role as the foundation of societal containment. While the psychological need for containment in a strong collective identity remains, this becomes harder to find within the political sphere.

These considerations lead to the question of where the best prospects for a revival of politics might lie. If we focus on the psychosocial dimensions of citizenship, we see the need for politics to offer experiences of identity and belonging that are emotionally

containing. The democratic nation state seems increasingly unable to do that. Yet. despite globalisation, we still live in a world of nation states, and, historically, the nation has been a source of imagery which is visceral and expressive while also representing (albeit typically crudely) the constraining demands of societal membership. The national governmental apparatus is still usually the ultimate provider or guarantor of the containing fabric of everyday life, from high courts and universities to road markings and rubbish collection. The electoral appeal of regressive ethno-nationalist parties in many countries testifies to the continuing potential of nationalist discourse to mobilise the disenchanted, and highlights the risks of abandoning nationalism to divisive demagoguery. The present narrow range of political possibilities would be widened by the development of an emotionally powerful nationalism, one that would enable the liberal democratic polity to reclaim its citizens and to offer them a containing blend of passion and responsibility.

All this is, of course, just words, and words that have not addressed the role of religion, or the importance of the material inequalities within and between nation states. Those inequalities are arguably the most pressing threat to both the social cohesion and the psychological health of a society. However, words are invariably accompanied by emotions, and emotions pervade politics. They shape, support, and subvert efforts to bring about political change. The meanings for us, as individuals of our "nation", is one source, perhaps for many a major one, of the conscious and unconscious emotions which we bring to politics as a whole. So, this book's enquiry into the psychology of popular culture and its implications for politics ends with the argument that a reconstruction of nationalism might be essential to the renewal of liberal democracy.

The frailties of liberal democracy

A psychosocial question

This book offers a new exploration of something that is fundamental to our individual wellbeing and to the health of our societies. It pursues one of the many answers that can be given to the question: what is holding us together? There is a very useful ambiguity in such a question. On the one hand, it asks what holds us each together psychically, what keeps us sane as individuals. On the other hand, it asks what holds our societies together, and keeps them functioning as collectivities. These are different questions; one is about psychic integration, the other about social cohesion, but there is a major area of overlap between them, a psychosocial area, which is where this book is situated. In the following pages, there is an attempt to answer the question in both its forms, and, thereby, to help develop a psychosocial understanding of the contemporary world.

The analysis to be developed in these pages is based in ideas deeply rooted in the psychoanalytic tradition (though it will not generally be assumed that the reader is already familiar with these ideas). Psychoanalysis has its dogmatic variants, but overall is a body of thought with a unique depth, richness, and capacity to illuminate

in surprising ways. The aim here is to contribute to a long-standing tradition of using ideas drawn from psychoanalysis in an open-minded and interdisciplinary way to explore social phenomena. In the hugely complex interplay between internal and external worlds that underpins all our experience and action, it might appear to be focusing more on the internal psychological side. Yet, it always considers internal states of mind in relation to what is offered by the external social world. Using that approach, the book concludes that contemporary democratic politics is not sufficiently meeting some basic psychological needs of its citizens—a dangerous situation which, *inter alia*, is feeding the rise of violent extremisms.

The basic ideas that run through the book are ones that some readers, especially among those who are well-versed in psychoanalytic thinking, might take for granted. They are that "containing" environments are necessary to hold individual minds together, and that such containment is offered by social structures which offer restraint and boundaries while also trying to meet individuals' emotional needs. The principal forms of popular culture act increasingly as important emotional containers for large majorities of people around the world. However, this growing importance of popular culture as containment has happened alongside an impoverishment of politics and a weakening of its capacities to contain us and to hold us together.

In this context, the analysis developed here challenges liberal cosmopolitanism to pay greater attention to the emotional meanings of the democratic nation-state, as one thing that "holds us together", and to the risks inherent in its devaluation. So, a psychoanalytic study of popular culture, when put in sociological context, leads us to a political conclusion. Recent events also point to the importance of this conclusion. In June 2016, the UK referendum on membership of the European Union resulted in the decision to leave, a "Brexit" from Europe. As one national example of the scale of popular disaffections with the globalised world, this suggests the need for defenders of liberal democracy to understand the dynamics of national feelings and the different ways in which those feelings can be mobilised. In another example, the election of Donald Trump has shown how a powerful electoral force can readily be fashioned using a combination of nationalist rhetoric with a deep sense of disinheritance and grievance, a mix familiar in European history but perhaps less so in the USA.

Where this book came from

This book was originally proposed as a second edition of one first published in 1994, under the title *Disciplines of Delight: The Psychoanalysis of Popular Culture*. The idea was to freshen up a work that, I hoped, still offered an original and useful approach to understanding popular culture, and to extend and update that approach with additional material, some published elsewhere in more recent years, and some written specifically for this book. However, it eventually became clear that the additional material was changing the scope of the book and giving it a new focus, which demanded a new title. So, it became a different book, albeit starting from a summary of the case study material that was at the core of *Disciplines of Delight*.

Any consideration of politics appeared only towards the end of the previous book. None the less, the politics of the time had, no doubt, shaped it. It was written in the early 1990s, a time of relative optimism for those who chose to feel it. The Cold War was over, we thought, Soviet totalitarianism had disintegrated (though into what was not clear), and there were some hopeful signs that capitalism-based liberal democracy could at least partially reinvent itself in the directions of greater equality, compassion, and inclusivity. In the UK, the Labour Party, of which I had been a long-term, if passive, member, had been reinvigorated and was promising to be a much stronger electoral force than it had been in the years of Margaret Thatcher's premiership. The self-righteous and punitive tone of her rhetoric had gone from centre stage, as had the banal certainties of Ronald Reagan's cardboard, yet frightening, presidency. Instead, the young sax-playing Bill Clinton occupied the White House.

The message of that book was a hopeful one: that popular culture was a rich and powerful resource for emotional development and self-fulfilment. That was hardly an original contention. Whatever originality the book possessed lay instead in its offering a particular psychological account of why popular culture, at least in some of its core parts, was both popular and a good thing. This account was based broadly on the object relations school of psychoanalytic thought, upon which I had been drawing for some years previously in order to understand various aspects of society and politics. It was also a contribution to the then emergent field of psychosocial studies, an interdisciplinary territory housing a number of efforts to integrate

psychoanalytic and sociological agendas. (Psychosocial studies has recently progressed to formal emergence as a scholarly field, with the formation in 2013 of the Association for Psychosocial Studies: www.psychosocial-studies-association.org.)

Unlike some other post-Freudian versions of psychoanalysis, object relations theory gives us a positive model of the self and identity. It sees a possibility of healthy psychological functioning, normally based on experiences of good and empathic care in early development, though reachable also through self-reflection and emotional effort at a later stage. While it accepts that sanity is, inevitably, always a work in progress, it affirms the possibility of "good enough" experience and relationships amid the profusion of inner conflicts and defences that underpin much of daily life. It does this without turning away from the overarching tragedy of loss and death beneath which we all live our lives. In fact, through its absorption of some of Melanie Klein's descriptions of human aggression and destructiveness, it presents a more elaborated and richer account than even Freud did of the painful core of human subjectivity.

So, as I will shortly describe in summarising the contents of this new book, the previous one brought this theoretical approach to bear on some key components of popular culture, in order to argue for their actual and potential contributions to a good society. In this project, I was, in some part, reflecting the stirrings of political optimism of the time, notwithstanding the continued commitment then of many people on the left/liberal sides of politics to an unrelentingly negative view of actual democracy in Britain. Finding myself somewhat at odds with that negativity, I wanted to write in an appreciative, even celebratory, way about some things which were very important to millions of people, including myself, as sources of pleasure and hope, and as antidotes to alienation and anxiety.

As an intellectual project, it seemed sufficient at the time to do so in a way that simply offered an overall theorisation about what some key cultural forms give us, emotionally, and why, therefore, they are both popular and valuable. There was hardly any psychoanalytic writing then about contemporary popular culture, and it was possible to subtitle the book "The psychoanalysis of popular culture" without having to be more specific. The present book, however, is just one in a whole series on the psychoanalysis of popular culture, and there has also been much other work in the intervening twenty-plus years.

None the less, the theory developed in the previous book is, I hope, no less accurate or relevant now than it was then. The fundamental psychodynamics of popular culture have not changed in the past twenty years. Neither will they, I would suggest, in the next twenty or more, but the analysis I offer can no longer stand on its own, unrelated to other developments outside of popular culture.

When *Disciplines of Delight* was published in 1994, the contours of emotionalised and therapeutic culture were still emerging. In many respects, of course, two decades ago was another world entirely. Email had arrived, but the web as we know it now was beyond most people's imagining, and social media would have been (social) science fiction. There was also less sustained attention paid in academia to the uses or applications of theory and research, no call for "impact", as the practical, societal value of academic writing is now officially described in the UK university sector. Neither had we fully entered the era of today's worldwide malaise of politics, in which democracy seems threatened from multiple directions: disengagement and low turnouts, discredited political classes, despotisms of various kinds, and theocratic fundamentalisms. In the political firmament of 2016, silver linings are harder to detect, and the clouds are darker, than they seemed in 1994. This is a time of unprecedented global turbulence, in which failed and fragile states are multiplying, and the political cultures of some of the most stable states are deeply troubled. So, this book ends with an attempt, based on the concept of societal containment, to draw lessons for politics from the study of the psychosocial dynamics of popular culture.

Since the late 1990s, my own interests have focused on two developments in politics: the decay of trust in national democratic politics, and the growth of fundamentalist and violent extremisms. My reference point is usually British politics, though both these developments are widely seen as international in occurrence and in origin. I will be suggesting that these two trends are related to the growing importance, in economic, social, and psychological terms, of popular culture. In order to develop this argument, this book includes three articles I have published since the 1990s, each of which (Chapters Three, Four, and Five) offers a broad contribution to psychosocial theory. Two were co-authored, one with Joanne Brown and one with Karl Figlio, and I am very grateful to them for those collaborations and for their permissions to include their work here. Much in those

articles is owed to them, though neither should be held at all responsible for the conclusion in support of which they are republished here. This conclusion, set out in the final chapter, is that a revival of *national* polities is an urgent objective, the pursuit of which needs to be linked to a careful and open-minded study of the emotional meanings of nation and nationalism.

Like the core argument of the previous book, this one is based on interpretative commentary, not on original empirical research. I refer to different sorts of empirical data, but use this as indicative material, not as conclusive evidence. I try to link, and make overall sense of, some diverse phenomena. For this reason, the book as a whole will disappoint those academic readers who seek methodological rigour above all else. I hope it will compensate for its academic unconventionalities in a more readable style. In dealing, as I am in the book, with some major questions about the nature of contemporary experience, I also hope to have avoided sounding glib or portentous, while still being clear about the depth and importance of the feelings involved.

Outline of contents

In Chapter One, I re-present the theory of popular culture advanced in my 1994 book *Disciplines of Delight*, through summaries of the case studies that were at the heart of that book, of football, popular music, and consumer culture. These show that the pleasures of libidinal and aggressive release offered in contemporary popular culture are interwoven there with experiences of the constraint required for co-existence with others. It is suggested that this combination of release and limitation is powerfully containing, and is what makes popular culture popular. Needs and desires are acknowledged and given expression, but in ways that reaffirm the power of the societal other— a power that is protecting and providing as much as it is restricting.

The chapter concludes with a brief discussion of how the understanding of popular culture which it has outlined will be developed in the rest of the book, and also of how it can be linked to Norbert Elias's account of the "civilising process". Elias argued that a gradual increase in impulse control characterises the development of modern societies, a process that can also be seen in terms of the elaboration of social containers.

Next, Chapter Two lays the foundation for a crucial expansion of the theory of societal containment set out in Chapter One. It was co-written with Karl Figlio, and first appeared as an article in the American psychoanalytic journal *New Imago* in 2003. It draws intensively on psychoanalytic theory, and takes two very specific examples of ordinary everyday experience. These are not examples of participation in popular culture, but simply reflective observations at moments of immersion in relationship with the societal other. In the first of these, the material infrastructure of society appears to a child as a deeply protective and reassuring good object. It argues that the neutral infrastructures of society (such as public urban spaces, and utilities) have a powerful containing function, through their representation of the protective and nurturant power, and the disciplinary functions, of the societal collective. In the modern world these infrastructures are typically guaranteed, if not actually provided, by the nation-state. In this role, the state is both underwriting and enhancing the increasing inter-dependence of people which Elias saw as the driver of the civilising process. This analysis is developed further later on in this volume, in Chapter Five, pp. 74–78).

In the second, a chance encounter with a street demonstration reveals the reassurance normally provided by the neutrality and settled mood of a public space such as a high street. It also shows, however, that such reassurance can depend on a defensive denial of the existence or extent of badness in the world. We offer an analysis of a typical response to such a demonstration, which was against the mistreatment of live animals during their export. It brought to the minds of those who witnessed it in the peaceable high street the existence of cruelty and death elsewhere, and so triggered in them the contradictory complex of feelings which can be evoked in everyone by such events: anger and guilt at the suffering, and a wish to ignore or deny it. This vignette demonstrates the potential ambivalence of societal containment: the containing calm and predictable order of public space can serve a sanitising and defensive function.

Chapter Three considers an inescapable feature of today's popular culture, one which has become more dominant in the past two decades. This is the frequency and intensity of emotional expression, most conspicuously in soaps and reality shows on television, and across social media. This might seem to be a banal observation, equivalent to noting that people are always breathing, but it was not always

thus. Also, emotion is now a major topic in the social sciences. Of course it is, one might think, since the social sciences seek to understand how societies work, and emotion is a major part of our social lives. Yet, it took over a century for social science agendas to reflect this; a "rationalist" bias kept questions of emotion off most of those agendas for a long time. Even in psychology, the study of emotion was a specialism at the margins of the subject. The "turn to affect" in studies of society began in the closing decade of the twentieth century. It was prompted, in part, by the cultural changes that had been in train for some decades before that in the developed consumer societies, changes towards greater emotional expressivity, which made it harder for academics to downplay the importance of emotion. An abundance of cultural commentary and social theory has now emerged concerning the trend in the late twentieth century and since towards the emotionalisation of culture.

This trend is one in which football, popular music, and some aspects of consumer culture have played large parts. It is part of a broader development that is about much more than emotional expression. There is now much more awareness of emotions in everyday life. There is also much more popular interest in our affective lives, where feelings come from, and how they can best be managed. The term "therapeutic culture" has been used to describe these changes. Although this culture is decried by some writers as sentimental or hysterical, the analysis presented in this chapter takes a different view, and sees the "therapeutic" trend as a major influence on popular culture with the potential to strengthen its universalising and humanising influence.

The chapter is an essay co-written with Joanne Brown, published in 2002 in a volume in the Gothenburg-based series "Studies in Contemporary Culture". We trace several roots of the "emotionalisation hypothesis" in the social sciences, and argue that the process of emotionalisation is not simply one of greater emotional expressivity. In fact, how we assess its overall significance and value, as a positive trend in culture or as fakery and self-indulgence, depends on the extent to which emotional expression is combined with both reflection and compassion. We propose a particular concept of "therapeutic culture" as a way of defining this constellation of values, which, in its blend of affect, reason, and conscience, is a clear echo of the Freudian tripartite model of the mind. The greater readiness to inhabit and

perform emotion needs to be accompanied by desires to understand it (its origin, nature, and effects) and also to use that understanding in compassionate and reparative ways.

Defined in this way, a therapeutic culture has as its key components not only a preoccupation with feelings, but also a belief that exploring the world of feelings (e.g., in "talking cure" conversations with a professional, or in everyday conversations with family and friends) can be therapeutic. Moreover, there is also a wish to use this knowledge of self and others for the greater good, whether that is in efforts to reach and support troubled individuals or to reshape professional practices, social institutions, and cultural patterns so as to enhance the emotional wellbeing of all.

This chapter is careful to acknowledge the regressive, inauthentic, and narcissistic forms that therapeutic discourse can take (features focused on by critics of the therapeutic, such as Furedi, 2003). The therapeutic shares that negative dimension with the discourses of "identity" with which it is closely linked. Overall, though, we argue for a positive view of the therapeutic, and of how it can produce what we call an "institutionalisation of compassion" at both the organisational and societal levels, building up a society's stock of emotional capital.

Therapeutic culture can function to increase the social, institutional, and cultural spaces in which containment can be found by facilitating the acknowledgement and working through of anxieties and conflicts. Infused by the therapeutic ethos, popular culture acquires additional containing potential. It has traditionally been a resource for the expression and tacit integration of sexual and aggressive impulses, and for "narratives of love and loss", to borrow the Rustins' phrase (Rustin & Rustin, 1987). Now, a very wide range of vulnerabilities, fears, and desires can be explicitly managed within its burgeoning therapeutic discourse.

The next and fourth chapter is an essay first published in the journal *Soundings* in 2000, in which the threads of popular culture, therapeutic culture, and politics are pulled together around the concepts of containment and compression. The concept of containment is the same as that used throughout this book, and applied here to the practice of political leadership, which, in the therapeutic age, is seen to require attention to the task of "emotional governance" (as I later called it in a book of that title). Indeed, effective authority in many

contexts, in organisational or informal settings as well as political ones, now rests, at least partly, on those in the positions of authority being able to recognise and manage the anxieties of those who look to them for leadership or regulation. The chapter argues that the much-derided practice of political "spin" is, or has the potential to be, an essential part of this work of emotional governance. In the public mind, spin is associated with deception and distortion in political communication. While the arrival of "spin doctors" in the 1990s did involve some professionalisation of these malpractices, it was also part of the broad "therapeutic" trend towards acknowledgement of, and engagement with, public affect.

The concept of compression is proposed here as a psychosocial elaboration of the concept of the same name developed in Harvey's (1990) theory of postmodernity and his concept of space–time compression. In the same way as modern transport and communication technologies abolish distance and transcend time, thus connecting hitherto separated people and events, so the general socio-technological conditions of contemporary life bring our emotionally diverse experiences together. The screen of a laptop, tablet, or phone has become a major example of this. Prior to digitisation and the internet, the experiences of work and leisure were physically separated, which consolidated the separation of the different psychic energies which they required. Within the leisure sphere, shopping and watching a film, for example, were activities necessarily conducted in different places and in separated time blocs, and mobilised correspondingly distinct and separated parts of the mind. As physical compartmentalisation dissolves, internal psychic separators become more permeable.

Perhaps this is a technological driver of the therapeutic principle of reducing internal rigidities and increasing self-knowledge. The consequent fluidity of psychic life has, of course, been described in various ways in the literature on postmodernity, for example, in the concept of hybridity. In this chapter, the case of President Bill Clinton is used as an example of how images of political leaders (as of others in the public eye) can reflect the compression into the same experiential space—that is, the public image of one person—of opposing or divergent psychic materials, previously experienced as incompatible (in his case, the superego aura of a President in the White House, and a scenario of oral sex). This analysis suggests that a publicly "compressed" leader, though not necessarily a fully "therapeutic" figure in the sense of

representing a greater capacity for self-change through reflection, will have more capacity to communicate emotionally with citizens than a leader whose persona is of the earlier sanitised or incomplete variety.

The increasing interweaving of politics and popular culture (e.g., politicians as celebrities) is a crucial instance of the compressive tendency, which is shown more generally in the rising importance of the emotional public sphere alongside the traditional public sphere of political debate. Overall, this tendency—while very mixed in its nature—offers some opportunities for greater reflexivity and psychic integration among the democratic public, and so for potentially enhanced containment.

So, interwoven with the rise of the therapeutic and its integrative influence is the increasing tendency for social discourses and activities linked to different psychic forces to be compressed, or fused together, in space and time, producing material and symbolic co-presences which both reflect and produce the growing exchanges between different parts of the mind. The classical Freudian model of ego, id, and superego provides a good vocabulary for describing this trend. Institutions that used to represent different mental agencies, which correspondingly occupied physically and symbolically separated spaces and spoke with different psychic voices, are now inserting themselves into the more fluid and multi-vocal discourses of contemporary culture. Advertising transformed the once sombre and forbidding bank into a gateway to pleasure (see Richards et al., 2000 for an empirical study of this development); rock concerts can be occasions for reflection on the traumas of others and for charitable giving, while also continuing to be rock concerts.

In the final chapter, the idea that popular culture is about containment is placed in a broader context, such that it is seen as one possible modality of societal containment. Another possible such modality is in the individual citizen's relationship to the state. This chapter explores the potential of the state, especially of the liberal-democratic state, to function as a container. It also considers the power of nations to provide our most potent large-group identities, and sees in the liberal-democratic nation-state a potentially powerful container. However, those nation-states are currently failing in that role. As their power to contain is declining, so that of popular culture is increasing. While that development in popular culture is, in itself, a good thing,

the move away from political containers leaves a dangerous vacuum in which democratic legitimacy fades and political extremism grows. To counter these developments, and drawing upon the book's thesis that societal containers must reach deeply into the needs and desires of the individual psyche, we end with the proposition that some re-enchantment of the nation is the best option for reviving democratic politics.

Politics was once a major source of containment for the public, given the intrinsic role of the state as quasi-parental container. However, in the present situation, it is being both invaded and over-shadowed by popular culture, particularly in its therapeutic and fused forms. Partly due to the impact of popular culture, which is at once globalising and individualising, politics—especially as a *national* phenomenon—is becoming de-cathected. However, it is also decaying in itself. Despite sometimes wearing the colours of popular culture, it cannot offer high levels of libidinal expression, and neither, in this anti-deferential age, does it reliably command subjection. Therefore, it no longer offers any containment to the public, as that now depends on an intense tension between compressed forces of desire and restraint, and politics offers little of either.

To regain the role of politics as a major container of public emotion, and, thereby, to rejuvenate democracy, it appears that some reworking of the political is required. It needs deeper, non-cosmetic links with popular culture, but, as the work of Volkan (2004, 2013) suggests, it also, above all, needs to capture the desire for connection in a contain-ing collective identity that values its specific nature but does not idealise itself. The suggestion to be made in this chapter is that a reworking and revival of the nation and of national feeling is the most promising direction in which to look for this change, especially if that feeling can be linked to therapeutically inflected and fused forms of experience. Ideologies of the nation tap into powerful libidinal sources, while also being able strongly to represent the restraints of civilisation. Historically, nationalist movements have often projectively split off the bad parts of both desire and restraint into extra-national outgroup "others", sometimes with tragic consequences. However, it does not follow that nation-states in the future will not be able to avoid these projective defences and instead offer to their citizens more integration and real containment.

The popular disciplines of delight

Modalities of containment

The concept of containment figures prominently in much of what follows. By containment, I mean that people are "held", emotionally, by the forms of popular culture that they consume. We are held together, psychically, by our internal capacities for self-integration, and by any confirmations of our selfhood and identity that we find in the external world. Foremost among these will be the experiences of recognition, acceptance, and reassurance which other people can give us in our interpersonal interactions, although containing experiences can also be available in our dealings with organisations of various sorts and in our consumption of culture.

In this book, the use of this concept draws heavily on psychoanalytic formulations of the idea of containment, including the original one found in the work of Bion (1962), but at times I might extend the term beyond stricter psychoanalytic definitions, towards a process which is sometimes captured in a more everyday, less technical way by the term "holding". This term also has a technical provenance in the psychoanalytic theory of Winnicott (1960), who uses it to refer to the "holding environment" provided by the mother or primary carer

in the earliest months of life, not least in the processes of physical care of the baby. While the idea of "containment" as used here has some connotative affinity with Winnicottian "holding", in that both are about supporting a sense of safety at a deep psychic level, the developmental functions of the "environment mother" cannot be taken on by cultural forms and societal structures, though perhaps they can be echoed or recalled for the developed psyche of the adult. In any case, debates about the technical meanings of these two terms, and the relationship between them, have continued without resolution among psychoanalytic writers (for example, Ogden, 2004; Symington & Symington, 1996), which gives some licence for the somewhat heterodox use adopted here.

The psychoanalytic literature on both these concepts mainly focuses on their importance in understanding the relationships necessary for healthy psychological development, and for effective therapeutic work; that is, they focus primarily on the carer or therapist as container/holder. However (as will be discussed more in Chapter Five), they have also had important application in discussions of how institutional environments such as children's homes or psychiatric residential units have an impact on individual states of mind. I am extending such uses to a societal level, and am proposing that, as well as playing a developmental role, the institutions and cultural forms of a society have an ongoing and necessary role in stabilising the adult psyche. They offer us a range of resources for emotional self-management.

My argument in *Disciplines of Delight* was that some major forms of popular culture offer very effective emotional containment in their combination of high levels of both pleasure and of societal constraint. They facilitate individual expression while also confirming social membership, thus enabling us to find ourselves as sensual individuals while reconciling us to the necessary authority of the societal other. Through them, we can "perform" the balance between release and restraint that is necessary to hold us together. They offer the reassuring and rewarding creations of human society as an antidote to our fundamental anxieties. In various ways, they can receive our anxieties, process them, and return them to us as tolerable—in fact, pleasurable—experiences.

In all, they are deeply functional for both individuals and, at a very fundamental level, for social cohesion. Individuals who are not held

together adequately through the combined functioning of internal and external containers can suffer in ways that do not impinge damagingly on others except those close to them. Alternatively, they might, over time, constitute a risk to social cohesion, whether this is because they engage in antisocial behaviours, crime, or violent politics, or, at lower levels of disturbance, just do not have the emotional resources to be actively good citizens.

All societies must, therefore, offer some modalities of containment to their members. These might or might not draw on popular culture. They can be more or less effective, and must do their work amid whatever forces might also, in any given society, be actively working in the opposite direction, not to strengthen containment, but to undermine or corrode the internal capacities for containment in some members of that society. The effects of inequality, poverty, and social exclusion are not only apprehended in external measures of material deprivations, illnesses, and reduced opportunities, but also felt in internal struggles against anxiety and fragmentation, and in diminished collective resources of emotional capital.

In later chapters, we go beyond the study of popular culture, noting its increasing importance relative to other possible modalities of societal containment, and considering the overall societal implications of this shift. However, before then, the general concept of a societal modality of containment is illustrated and elaborated through case studies of key forms of popular culture.

The heart of the popular

What makes popular culture popular? Why are we so passionate about the forms of sport and music that now reach around the globe? What is the appeal of the experiences that many people see as their main pleasures in life, with which they seek to fill their leisure hours and around which their social lives might be organised? Whether we are applauding or bemoaning the influence of popular culture, we pay very little attention to this most basic of questions: why *this*? Why these particular activities, these forms of expression?

This chapter offers an answer to that question. It focuses on three particular forms of popular culture. Two of these are now the most dominant forms in their global reach: association football and pop–rock

music. The third is the diffuse, almost limitless, domain of consumer culture, our discussion of which involves a brief excursion into the countryside.

Although all sports excite passionate involvement among those who play or follow them, the twentieth century saw football rise to a unique position of primacy in global popular culture. The two most populous countries in the world were not represented at the 2014 World Cup finals, but global television audience figures for the final match of nearly one billion suggest there is, none the less, a *prima facie* case for seeing it as the most widely followed international sporting event, or, at least, holding joint first position with the Olympics. Because of its place in popular culture, football is now also heavily populated by an international plutocracy. Also, it is part of the international world of soft power, as in the successful Qatari bid to host the World Cup in 2022, but both of these developments depend on its power to capture audiences.

Notwithstanding old stereotypes of footballers and football crowds, the game itself embodies a high level of development of the civilising process. This is because the taboo on which the game entirely rests is a particularly stringent one: it is a taboo on touching by hand. So, the rules of the game embody an intense form of social prohibition: we are manually focused creatures, and to be deprived of the use of our hands is to subject ourselves to an especially invasive restraint. Yet, the same time, the game offers a wide range of opportunities for the satisfaction of aggressive and aesthetic impulses and needs. The force of the taboo rests not only on the negative threat of exclusion or punishment. It also derives from the positive experience of observing it, from the delights of participation.

In this combination of restraint and release, football embodies a dramatic representation of social membership, in the general sense of belonging to human community. It has an intrinsic appeal, a major part of which is that it mimics society as a whole. At the same time, it is the vehicle of some of today's most powerful partisan identities. Identities often involve some measure of idealisation of the group or collective with which one is identifying, and that is certainly the case with football partisanship.

Idealisations can differ importantly in quality, being more or less defensive, and their social significance will differ also according to their object; compare the fascist politics of an emotional investment in

an idealised "white Britain", purged of bad elements, with the demo-cratic politics, albeit not unproblematic, of an image of an idealised multi-racial Britain, purged of conflict. However, the extent to which football—like any other sport—is a constructive and reconciliatory force in society depends upon its universal, intrinsic appeal outweigh-ing its appropriation by partisan sentiments (necessary and, at times, constructive though the latter might be). That universal appeal, the glorification of the game itself, might involve some idealisation of society, which we are to hope will outweigh the glory of winning, the idealisation of the in-group. It is captured in the rituals around partic-ularly important matches, as I have tried to show in an essay on the FA Cup Final (Richards, 2014).

In the expanding universe of popular music, with its proliferating genres, there can be no such global coming together of all its devotees. Indeed, it is far from obvious that we can talk of pop/rock music (Regev, 2013) as a single, broad phenomenon, so varied are its forms. Still, I suggest that the general development of popular music in the second half of the twentieth century created new spaces for interna-tionally shared and compelling cultural experiences. Often seen as the core of popular culture, pop music is inviting territory for any examina-tion of the emotional dynamics of the popular. The role this music plays in facilitating adolescents' separation from their parents has long been widely recognised, and, since musical subcultures supporting young people's "identity" work began to flood mass culture in the 1950s, most people alive now in the developed world, and many outside it, have had the opportunity to participate in that kind of musically based self-development. Moreover, many of us have found it continues to be an indispensable resource long after the chronological adolescence has run its course. For the postmodern subject in a world of flux, the work of stabilising the self is never done. We are constantly revisiting the anxieties and achievements of emotional development, with music acting as a guide to both for many people.

An important part of this work is undertaken in the context of inti-mate relationships, particularly in the making and breaking of attach-ments to sexual partners. In the vicissitudes of love life, we recapitulate the joys of union and the pains of separation and loss which were first experienced on the developmental journey, and pop music offers abundant articulation of, and containment for, the anxieties associated with loss. The blues music of the mid-twentieth century is a powerful

language of loss which has deeply shaped pop music and which continues to be drawn on directly by new generations of artist. All music represents societal disciplines through the structures and conventions of its form, and all music presents opportunities for deep engagement with both desire and anxiety, along with models of how turbulence and loss can be survived and managed. However, pop music does this in highly accessible ways that, alongside the celebrating of romantic love, also confirm the reality principle, that loss is loss.

Contemporary popular culture is entwined with consumer culture, and there is much potential for object relations psychoanalysis to illuminate our lives as consumers. In both our experiences of goods themselves, and of the promotional communications designed to interest us in them, we can find evidence of the ways in which popular culture provides us with objects and images that we can then use to manage ourselves emotionally. The role of advertising is crucial in this process, in the ways that advertisements can offer particular resolutions of psychic tensions. In a study I conducted with Iain MacRury and Jackie Botterill, we argued that this typically involved some resolution of the conflict between desire and authority. To that end, advertisements act as a cultural resource, a set of templates perhaps, available to all those people who noticed them, whether or not they were influenced to make purchases of any particular goods. (See Richards et al., 2000.)

A key material object in the popular cultures of all developed consumer societies is the car. This is an object capable of evoking regressive satisfactions in the offer of safety within a pseudo-maternal body, as well as bearing the more familiar excitements of sexualised self-experience as powerful. These pleasures are paired with psychic risks: for example, the exposure to the guilt that is always at hand when aggressive impulses are given licence to be expressed. As well as the very libidinal and aggressive dimensions of the car, there is also an important dimension of its appeal linked to the simple fact of its bestowing mobility upon its driver. It endows us with the capacity of controlling movement of the self, and, in a superhuman way, thus linking the baby's pleasure in early mobility with modern cultural valorisations of individual freedom to move and travel.

However powerful the unconscious resonances of the car and driving might be, any pleasures they deliver for the individual can only be received within a highly constricting environment of rules and limits, both physical and legal. The ordinary recurrent pleasures of

"motoring" derive from its being embedded in the tasks and leisure activities of everyday life, from the moderated exercise of libidinality and from skilfully and safely dealing with the challenges posed by the encounter of the car's power with the constraints presented by roads, other traffic, and the parameters of civilised behaviour.

The car is, therefore, part animal, part model citizen, both wrapped in a technophiliac package. It is, on the face of it, a very different kind of thing in the unconscious to the gentle British countryside, whose pastoral idyll is the technophobe's retreat. The countryside is also usually thought of as a counterpoint to consumer society, a balmy escape from it. Yet, at the same time, it is impossible for us not to "consume" it, as our routes to access it are partly commodified, and images of it are deeply embedded in popular and promotional culture. Also, like the car, the countryside's appeal rests on its combi-nation of a deep libidinal register, as in our experience of its beauty, with the order and constraints imposed by human society, which we encounter in the ways that historical human labour has fundamentally shaped the agrarian countryside. Moreover, the symbolism we use to describe our sensuous encounter with the countryside indicates that, at least in our unconscious experience, it is, like the car, a body. The significance of this for our experience of the nation we inhabit is picked up in Chapter Six.

In each of these case studies (which were examined in greater depth and detail in *Disciplines of Delight*), a common pattern emerges. We see that the magic of football, the rich appeals of popular music, and the power of the car as an object of consumer desire all depend upon a particular kind of experience. They all offer a combination of intense pleasure with high levels of social discipline. The pleasures involved are fundamentally of a bodily, sensual kind, and the partic-ular power of these cultural forms lies in their ability to deliver such pleasures to a maximum, while also strongly affirming the social rules that must govern us if human society is to be feasible. They provide a particularly intense encapsulation of the experience of being human. Cultural forms that can do this have the power to bring people together through a universal experience based on a fundamental commitment to membership of a human collectivity.

Elias's sociological theory (1978, 1982) of the development of human societies can be seen as providing a historical framework for this analysis of contemporary culture, and an explanation for why the

dynamic of pleasure and restraint is so compelling. His account of the "civilising process" suggests that, as the division of labour in human societies increases and produces widening networks of interdependency, regimes of impulse management are increasingly adopted in order to avoid or manage conflicts with others or impingements upon others, and to facilitate co-operative living. The emergence of modern states with their monopoly on the legitimate use of violence is a major contribution to this process. However, from a pessimistic Freudian perspective, the costs of this civilisational repression are potentially catastrophic, since the unruly forces of libido and the deathly potential of aggression are always on the edge either of overturning civilisational repression and breaking our social bonds, or of destroying us individually from within, through neurosis and madness. Eliasian theory posits that this problem of potential catastrophe can be addressed in the evolution of cultural forms that permit "controlled decontrolling" (Elias & Dunning, 1986). A leading example of this development in the civilising process is sport, as seen in the account of football given above.

Essential to such phenomena is that, fundamentally, control remains in place, and, indeed, is strengthened by its relaxation. The containing effect of such cultural forms is based on the way that they demand confrontation with, and basic acceptance of, the societal "other". In Freudian terms, this can be seen as a reconciliation or, at least, a truce, between superego and impulse, managed by the ego (with the support of society as auxiliary ego as well as superego object). In other words, some degree of psychic integration has occurred. Containment and integration can be seen as different moments of the same process.

It is not only impulse which is the object of containment: anxiety is also at the heart of what is "contained", as will be seen in later discussion of Bion's model of container–contained. Impulse meets societal other and gratification is mixed with boundaries and the safety of community. Anxiety meets societal other and, again, safety is found in reassurance, in the detoxification of fear.

In Chapters Three, Four, and Five, it will be argued that popular culture is becoming increasingly important as a container of impulses and anxieties, especially so as the popular becomes increasingly inflected by what will be described as "therapeutic culture". Politics, meanwhile, is becoming an increasingly ineffective container, mainly,

though not entirely, as a consequence of the cultural trend towards deep suspicion of authority. There is a malign feedback process here, since the credibility of politics in any society—and, thereby, the stability of its political institutions—depends on the political process having some power to contain its citizens and their psychic needs. Hence, the call at the end of Chapter Five for considering the renewal of the democratic nation-state as a key container in the field of politics.

The containing matrix of the social*

A note on method

This chapter is an experiment in cultural analysis. Rather than use an artefact, such as a novel, film, or painting, we base our analysis on two personal experiences. An artefact, which is available to anyone, has the advantage that anyone could compare what we say about it with his or her own view, and arguments could be tested against each other. The advantage of personal experience is that the theory is part of it, an account of it in the mind of the subject who had the experience. It keeps the theory close to the experience, and invites others to report in a similar way. We know that it raises all the difficulties that occur in reporting private experiences from the consulting room, and adds to them the absence of a regulatory process, such as the transference in clinical work.

If we were to look for precedents to ground our experiment, we might call upon the engaging essay by Freud, "On transience" (1916a),

* This chapter is a slightly revised version of an article, co-written with Karl Figlio, which appeared in 2003 in the American psychoanalytic journal *New Imago*, *60*(4): 407–428. It presumes some familiarity with psychoanalytic language.

which one could read as an experiential theorising that is equivalent to the more formal "Mourning and melancholia" (1917e). Freud used the occasion of a country walk with two friends as an occasion to reflect on the nature of mourning and the defences against it. He had concepts to hand, through which he expressed the poignant sense of despair that eroded his friends' appreciation of natural beauty. He apparently used these concepts (narcissism, libido, cathexis, melancholia), more or less explicitly, to persuade or, better, to fortify, his friends. He neither derived them from, nor proved them through, the experience on which he reported.

We shall give two reports of an experience. We have concepts at hand, two in particular. They will structure the articulation of the two experiences. They are "containment", as defined by Bion (1962), and "depressive anxiety", as defined by Klein (1935). We shall work outwards from personal experience to an understanding of the social situation of the experience, or, rather, we will see them as intrinsic to each other. In our view, the social situation—in the abstract, society—should be understood neither as the setting or backdrop for personal experience nor as the aggregate of social interactions. Social life is *lived*, assimilated to personal experience, and personal experience is, from the outset, social. We begin with personal experiences, and with minimal theoretical elaboration, because they are the medium in which social is lived; everyone is a spontaneous theoriser and interprets experiences as they go along. Like Freud, we would like to persuade you of the validity of our perceptions and of the psychoanalytic expression of them, and invite you to contribute your own.

Our approach links the psychoanalytic focus on psychic "primitivity" to accounts of human community at an equally primitive level. In our view, the metapsychological concepts that best capture this idea of fantasies held in common—community fantasies—are Bion's idea of containment and Klein's idea of depressive anxiety: society is a container of primitive anxieties (Hinshelwood, 1989, pp. 244–250), and, in particular, of depressive anxieties. Just as containment is a process, not a static structure, our concern in this chapter is not with settled social structure, but with the "social" as the capacity to contain primitive anxieties. One way to look at this process is to think of the fluid responsiveness of a mother with her baby. A primitive social matrix builds up from the unconscious demand made by one person upon an other (Figlio, 1998; Hoggett, 1989).

Our psychoanalytic approach to understanding the everyday experience of social membership departs from one of the traditional definitions of social psychology, which has assumed that individual experience is directly shaped by societal processes, as in the study of, for example, social attitudes. We draw on material from two papers, one by each of the original authors. The first example concerns childhood, and allows for a certain discrimination between the naïve immediacy of the child's theorising and the more abstract, structured theorising of the adult. The second example comes from a recent event—a demonstration—that precipitated itself unexpectedly into the course of everyday life, and, thereby, forced into awareness the spontaneous interpretation that constitutes social life.

Public utilities in the unconscious

One of us (BR) recalls an experience from childhood, of being driven home at night in the family car after being out for the day, usually visiting grandparents in another town about thirty miles way. Driving in the day, there are all sorts of things for a child to look at out of a car window; at night, in contrast, there is not much outside of built-up areas, just lights: the lights of other cars and the shapes that briefly form around them, road lighting where this is present, and lights from houses and other buildings that one passes along the road, or sees at a distance. At one point, we would come over the brow of a hill and see the city where I grew up spread out before us: long, bold lines of orange lights, shorter squiggles of yellow and white ones, and countless individual ones of various hues, rather like stars, each one of which you could stare at, and imagine what it was and what it would be like if you were closer to it.

This was no starry firmament; this was a city. The experience I want to recall could be described quite simply as being one of being *reassured* by seeing these lights, but I want to suggest that the reassurance involved is of a particular depth and quality. The lights that we passed were evidence to me not only of the existence of safe places in a dark night, of a bright hearth beside which comfort could be found, they were also evidence of something less maternal, more abstract. The lights spoke of a society, an economy, and even, perhaps, of a polity, spread over the land. They spoke of connection, not just of the

concrete recollection of hearth and home. There were human reasons for all of those lights: each one shone in testimony to some human decision, and each one administered to some human need. What it all signified to me was the existence of a human collectivity that brought order to the world, including light itself, of course, the most powerful symbol and medium of human reason, but it more generally and profoundly brought the whole set of arrangements—material and social—that enabled us to live the lives we do. The same lights were at once both individual foci of recollections and imaginations and integrating networks of human social life.

Of course, your witness in the back of the car would not have put it in quite these terms at the time. My interpretation is retrospective. However, it was retrospective even at the time, and, over the years, I have added countless other moments of moving effortlessly from an initial, perhaps concrete, association ("that is reassuring, like home"), to a sense of an integrating social matrix. You might object that I am falsifying experience: maybe it was not as reassuring as it seems from the distance of nostalgia. That would miss the point. The experience might indeed be "false", in the sense of idealised, and increasingly idealised as the years pass, but my aim is to point out the movement of primitive experience, including anxieties, into the spontaneously generated social world that, reciprocally, contains them.

In childhood, one tends to encounter society and its arrangements in fairly concrete ways, in the physical fabric of the home and the objects contained in it, in the walls and pavements of one's neighbourhood that one is physically intimate with. Its more institutional forms do, however, make their presence known from an early age. The idea of a government begins to be understood, and some conception of a wider social authority must be developing from the early time when it becomes evident to an infant that its parents' authority is not global in its reach. We are talking here about the psychic space occupied traditionally by royalty—more apparent, albeit vestigial, in the UK than, say, in republics, but just as important in all societies. It is a zone of articulation between fantasy and social arrangements, in which material, social, and political functioning provide psychic stability in the face of unconscious forces at the same time as they satisfy utilitarian needs. Our analysis, thus, has a strongly modern basis to it, despite the underlying images of royalty that are, in their origins, premodern.

The state of mind I am trying to address here is one that has been possible only since the twentieth century; that is, in the era of comprehensive public utilities and a national road and rail network. It is a state of mind based on the experience of all those utilities in place, and functioning as the infrastructure for everyday life. There are taps, there are toilets, there are switches, there are trains, and roads with lines painted on them. And there are all the architectural creations that surround us, from the grand ones we stand to admire to the endless garden walls and fences that flash past the car or train window.

In addition, there are conversations: not just those in the home and on the street, but those wider societal ones that take place in the newspapers and on television, radio, and the internet. It is these conversations that most powerfully enfold us and permeate our internal worlds. You can get away from the interpersonal conversations of home and neighbourhood, and, indeed, you might at times need to, but you cannot get away from the societal conversation—usually you do not want to, unless the presence of society has entered your mind in a persecuting way—or from the internal conversation with which it is in an intimate relationship.

I am touching on two large issues, which we will not pursue beyond the needs of my argument. One is concerned with the place of images of society in the origins and phenomenology of madness, but madness is an extreme of the normal, so, the second issue is the part played by the experience of society *in general* in the development of an individual's feelings about *particular* societies, especially the one in which he or she lives. It might be plausibly suggested that the way the social infrastructure is experienced during early development will influence intellectual or ideological attitudes towards one's own society in later life. Those who, as adults, feel radically disaffiliated from their society are reproducing an infantile or childhood relationship to a social world that was not *then* experienced as being good and, by contrast, the strength with which society was experienced as a benign and supportive presence will integrate one into the social fabric.

I mean a particular process, not just a continuation of good and helpful feelings. What I am talking about, and trying to illustrate with my example, is a mode of containment. I was saying that I felt contained by the lights. I am describing how the material fabric of a society, and how the institutional and collective processes of which that fabric is a product and an expression, can play a part in the

containment of anxieties, and I am linking this containment particularly to the physical infrastructures of (late) modern society.

It might be that the kind of containment I am talking about occurred in premodern societies, but, in the absence of a dense, continuous, physical presence of the social, it would have been carried more by rituals, by the intense, if episodic, regimes of psychic management that rituals embody, and by manifest symbolic associations, as in the layout of a village or rituals that accompany working. In a more physically ordered and densely social environment, the containing function of ritual is dispersed into an everyday life that seems far removed from symbolic associations. It is in the timetables of trains and buses, in the regularity of news broadcasting, in the general management of time and the scheduling of activities (Harrison, 1971, Chapter 2; Thompson, 1967); it is also in the management of space by architecture and engineering. Additionally, it is generalised into the simultaneous presence of people joined into "imagined communities" (Anderson, 1983) in which the strings of streetlights mean countless people in the same "place".

Of course, the point needs to be made that this containing function, which I am attributing to streetlighting, tarmac, and the like, is not of the same order as the containing function of the mother, nor of any human agent. In a narrow, technical sense, what I am talking about is probably not containment (Hinshelwood, 1989, pp. 246–253), because the container is not an agent, like mother or an other, capable of providing the containment: receiving, responding to, and modifying projections. There is projection, but no reception and detoxification in the way specified in Bion's concept of containment. Institutions can contain, as the work of Jaques (1955) and Menzies-Lyth (1959) in the 1950s made clear, but simple material things cannot *in themselves*. (See, however, Searles (1960), on our intense relationships with the inanimate world.)

The role of the public utilities in the life of the mind must, therefore, be, in an important way, the creation *of* that mind; that is to say, their containing function must have been projectively invested in them. From a psychoanalytic point of view, the role of the parents is crucial, mainly in providing the primary experience of containment, which can then be internalised and projected into other people and objects, and secondarily in mediating the child's experiences and perceptions of the social world through the parents' own unconscious

fantasies and conscious feelings about that world. At the same time, the material world of a modern civil and industrial society has unique features that contribute to the form of containment and, crucially, expand the possibilities for its occurrence. We will consider this influence later.

Direct action: revealing the tragedy in ordinary living

Let us leave the notion of containment by a material environment produced by human beings for the moment, in order to develop a related theme through another example (provided by Karl Figlio). In this case, we are interested in the way a situation suddenly irrupts into daily routines that otherwise would be lived by habit, outside awareness. Therefore, it brings into awareness latent social structures built around the primitive anxieties and the containing function we have described.

First, we want to set the scene. In the heat of July, residents of Greenwich, in London, barricaded a main road and brought traffic to a complete stop. Drivers were trapped in the fumes of their own exhausts as the local people blocked their passage into central London. The action upset an assumed right to travel without a thought of its consequences, and it threatened to spread to the local residents' suing the borough council for not having closed the road itself, and, therefore, for not having taken responsibility for the rise in atmospheric pollution.

There have been many other instances of direct action in recent times. Greenpeace boarded an abandoned oilrig scheduled for sinking at sea and, by promoting a boycott of Shell products, forced the company to change its plans for decommissioning the rig. Protestors have delayed the construction of roads by camping in tree-houses to hinder the cutting down of trees slated for clearing and by burrowing under construction sites. Considerable numbers of ordinary people in the UK have turned out time and again to block the export of live animals for slaughter in other countries, because they have thought the transport cruel.

Direct action heightens the immediacy of an emotional experience of connectedness between people and between events. It intrudes into the anaesthesia and detachment of everyday life. In the Greenwich

protest and related activities, it brought into awareness the connection between driving and childhood asthma, which had become an epidemic. It is a form of dramatisation, in which the theatre is an everyday setting: a street, an office, a port. It often makes use of mimesis, as in playing dead to show the effect of nuclear war, or in wearing gas masks, or in road protestors tying themselves to trees or the disabled to trains, so that their eviction dramatises the exclusion of residents from political effectiveness, or of the disabled from ordinary public transport. It takes place in public. It aims not just to change a policy or an activity, but to effect that change through galvanising popular imagination and will. It is a form of popular protest, in which we can see the process whereby a passionate demand gains in strength and irrupts into action.

Recently, I stood at the side of a main street, one of many Saturday shoppers who had unwittingly become the audience for a demonstration against the export of live animals from a local port. Everyone would have shared an awareness of the issue. Feelings had been running high against trucking animals, often crowded and without water or food, for many hours at a stretch. Relentless picketing had nearly closed ports, which were kept open only by police protection, and the images and arguments surrounding the trade in live animals had been in the daily news. The marchers made their good-natured way slowly down the street, chanting, handing out leaflets, carrying gruesome pictures of animals, herding their children along. My feelings alternated between a wish to join them and, on the other side, to condemn them; the dramatic, theatrical possession of the moment divided my feelings, leaving little in between: no reservation or judgement, no compromise or goodwill for the opposing view of the moment.

Such a demonstration takes place in public, but only minimally so. Most of the people present have not assembled for official purposes, and they do not think of themselves as having gathered for a purpose, or as an organised group, or even as "the public" or "the people". In fact, they have been turned, without their consent, into an audience, drawn out of private lives that, until this moment, were, at most, facets of a sense of community. They find themselves in a makeshift theatre when they thought they were carrying out essentially private activities, such as shopping, eating, chatting with family: things that many people do in the presence of others, but without a common

intent that knits them into a public body. They are surprised at the intrusion into their private lives, even when, as in this case, the issue that drives the garnering of their attention is well known to them.

This theatrical moment shared with the moment in which the network of lights reassured the young nighttime traveller, the stirring into awareness of an unconscious social matrix. The difference lay in its schismatic impact, which contrasted with the containing connectedness of the lights. The demonstrators, with their lurid images, did not stand for the community, but for a faction. One might say that they invited identification with helpless animals or with brutal executioners. Idealisation of non-brutality replaced the containing space.

Members of the public, in this minimal—even subliminal—sense, do live in a containing space: they expect traffic laws to be respected, the shops to be open, prices to be fair and reasonably consistent, police to be available. If their intentions were more formal, their sense of common purpose and expectation would be greater. People would have constituted themselves as an organised group with customs for carrying out their aims. Theatre could less easily irrupt into such a public gathering. But here, in this minimally public space, the looser sense of common purpose could easily be disrupted.

Earlier, we tried to evoke in the reader the experience of the geographical, material, technological and social environment as a containing space, into which the projections and parental responsiveness of childhood were invested and dispersed. Let us explore the setting of this demonstration with the same aim. The town centre through which it passed is still largely enclosed by a Roman city wall. The town has pushed beyond the walls, sometimes through visible breaches, sometimes simply by dwarfing and overrunning it, or even through including it in the walls of later buildings. The town no longer coheres through being inside a defensive enclosure, but because it is a juridical domain, and a matrix similar to that which we described above.

Such a social organism is challenged by the irruption of a new problem. The spontaneous is outside the rules. Society establishes a territory, and in the territory people are discomfited by the unruly and will treat it as a threat. In the extreme, they would be terrified, a word and an idea that shares its root with that of territory. Such an unease could be better visualised and, therefore, more simply experienced, if there were still a functional city wall: outside the wall, the territory is

uneasy; inside, it is secure, and defence includes projections that serve as a virtual fortification in support of the physical perimeter.

In the case of a town in the UK, the environment that absorbs these projections is normally friendly; indeed, the projections themselves might be compared to those of a mildly anxious baby with a nearby, but not immediately present, mother. Such a mother is created by the projection of an internal mother into the environment. It is comparable to the network of streetlights described earlier, in that it "receives" anxious projections, in the sense of their representing the connected thoughtful responsiveness of a good internal mother. As an externalisation of the baby's fantasy of its mother's mind, the lights have an internal structure, as does the territory of the town created by a group fantasy rather than a perimeter wall.

I want to examine more closely this moment when the demonstration irrupted into a public space. I had been, with others, a shopper with a family, a market-day pedestrian on a typical high street. We were joined by the common idea of being shoppers, yet were separated by our unique personal situations. We were mainly pursuing private aims, but in a setting sufficiently public to invest us with a sense of citizenry, with everyone reinforcing the sense of a common social identity in the very process of fulfilling these private aims in a setting. When the demonstration broke into this setting, it did so with schismatic force. It challenged the sense of common purpose and identity: indeed, the very idea of a balanced view of the world that had legitimised the peaceful pursuit of commonly accepted aims, even if they were originally private aims.

I think such an irruption into the public, and the unease that it reveals, as well as causes, contains two conflicting aspects. On the one hand, it makes people *feel*. It breaks through the civility of the public space and makes connections. It says, in a dramatic form, that eating meat means that animals will suffer, rainforests will be cut down, local economies will be destroyed. It makes people feel guilty or sad about a neglect that amounts to an unconscious attack upon helpless creatures and human beings. It provokes people into the responsiveness that the streetlights symbolise.

On the other hand, its force is schismatic. Just as surely as it evokes guilt and sadness, based on a recognition of unconscious aggression and an identification with the wounded objects of attack, so, too, does it provoke defiance and repudiation, or perhaps idealisation of the

community as benevolent. Its effectiveness tends, therefore, to be ephemeral. Critics say it lasts only as long as a particular galvanising issue can be kept alive. If so, a sad but sobering opportunity is lost, as concern for society as a whole fades.

Society as a manager of guilt

Let us turn first to the moment of guilt and concern in the spontaneous unruly irruption. We should also keep in mind that the demonstration might have been well planned, and not at all spontaneous: the spontaneity occurs in the transformation of the public into an audience. In that moment, they are also exposed unexpectedly to a return of repressed objects, the most distressing of which are mutilated and dead (Fairbairn, 1943). The case might be clearer in the case of an animal rights demonstration, in which animals maltreated by crowding, experimentation, or slaughter can easily represent such internal objects, but it can be generalised to cover all the most distressing situations.

Society, by its very existence, defends against an irruption of mutilated and dead objects. From a functionalist point of view, that would be a prime function of a social structure, and one might think of classifying societies in terms of the types of defensive action that they employ against depressive anxiety. In psychoanalytic thinking, such a social function is a "social defence system" (Jaques, 1955; Menzies Lyth, 1959). In the extreme, such a system would become tyrannical, and, following Freud, we can look at the extreme in order to throw a sharper beam of light upon the ordinary. Thus, there could be a democratic tyranny, in which otherwise liberal ideology and political processes also defended against depressive anxiety.

For Meltzer (1968, pp. 143–150), tyranny arises from an inability to restore dead or mutilated objects. In Kleinian terms, this compromised reparative capacity arises from the denigration of those good internal and external objects that, like good parents, restore the child's world after his attacks upon them. The consequent depressive anxiety—that is, anxiety at the destruction of good objects—is avoided by a retreat to a paranoid mentality in which these mutilated, dead, and, therefore, dangerous objects are pushed away, but terrorise the self. In the absence of good objects that can instil confidence in the capacity to

repair a mutilated world, an illusory safety is provided by identification with a destructive, omniscient, and omnipotent object. Such an object will not fall victim to helplessness, uncertainty, or insecurity and it gains its illusory strength through attacking just these aspects of the self. The tyrant is a bad object that promises safety from attack by pushing uncertainty into outside groups and inviting an alliance in destroying them. In an environment in which mutilated objects are circulating, such an invitation spares people the dread of exposure to them and to depressive anxiety. People dread the loss of the tyrant–protector.

The main characteristic of the tyrant is that he or she exterminates depressive anxiety, helplessness, and uncertainty. The tyrant's apparent omniscience and omnipotence are not primarily in the service of suppressing rebellion, but in that of seducing potential followers into an addictive dependence on a protection racket. The goodness of the breast can be cynically replaced by arrogance; generosity and reliability can be replaced by a guarantee to exterminate uneasiness.

The immediacy of direct action creates a situation in which primitive anxieties and processes break through an organised defensive structure. That is the taproot of its power. In the structure that it disrupts, which we are calling a democratic tyranny, the state offers protection against the depressive and other anxieties that it also exacerbates. No aggregate of individuals can control the emission of carbon or carcinogenic hydrocarbons, the nitrate enrichment of rivers, or the oestrogen-imitating contamination of food. The fantasies of inner destruction evoked by undermining of the resources of life, or by any large-scale catastrophe, are charged with depressive anxiety, which cannot be assimilated in a structure built upon protection against that very depressive anxiety. The structure built on unassimilated fantasies, ineffectiveness, and state protection then settles into an apathetic paralysis. Direct action disrupts just such a structure and creates an opportunity for external and emotional reality to come together.

During a demonstration against the export of live animals, a protester was accidentally killed by a lorry carrying lambs whose progress to the port she had tried to prevent. In the aftermath, the evident grief of the protesters seemed to confuse their deceased ally with the lambs, as if they were equally victims of torture. Defiant protest by otherwise uncomplaining people, based on an identification with maltreated inarticulate creatures, expresses a deep unease.

The baby animals about to be slaughtered represent a dramatic return of the repressed fantasy of dead and mutilated objects. The protesters, in their identification with these babies, persecute the consciousness of society. The population divides between those who identify with the lambs and those who identify with the tyrants.

We have used Meltzer's analysis of tyranny to throw light on the pressure of depressive anxiety in society. The emergence of depressive anxiety into social consciousness can be promoted by direct action, which links repressed internal objects to the external objects, such as animals, that it consciously defends. Tyranny is an extreme social form that offers a defence against depressive anxiety; "society", in the broad sense of common purpose, displayed in the loosely organised public space of the high street, as well as in the highly organised form of political debate, is its ordinary form.

Society as collective imaginative effort

There is a dilemma inherent in the very directness of direct action when a group expresses unease on behalf of society. Dramatisation makes people *feel*; that is a prime intention of direct action. That is good, compared to the frozen state of democratic tyranny. However, dramatisation, as Hinshelwood (1987) shows, aims to hand feelings on, to displace and ultimately evacuate them from a group. Depressive fantasies and anxiety are not assimilated and mitigated, but are pushed into any group that cannot resist their imposition. People going about their business who suddenly and unsuspectingly become an audience readily attract these fantasies.

Direct action creates a dramatic moment in a public space that is neither expected nor part of the setting. It is theatre outside the designated place for theatre. When protest irrupts into an ordinary public space, it makes ordinary citizens into an audience for a drama that occurs in the midst of their public life.

Public life has, partly, to be actively maintained and, partly, to be unconsciously maintained in the imaginative space we described earlier. The scenario of citizens going about their business requires such a mixture of active and imaginative effort to hold the idea of a society or a state. Depressive fantasies and anxiety have to be assimilated through a continuous exchange between each citizen's internal

world and that citizen's environment. The external world will display their fantasies of internal damage and repair, and will contain objects that can be introjected to shore up or to undermine their internal worlds. Both the physical and the social environment take part in this continual interchange between individual internal worlds and a collectively maintained matrix of social life.

One can easily find examples of this process in everyday life. The counter staff at the station who remember that you buy a particular ticket contribute to the belief that life can be restored, just as the reappearance of mother's face in peek-a-boo adds to the baby's faith in his capacity to restore her from the death blow he dealt her by covering his eyes. The sewage pipe at the river's edge releases an effluent of objects damaged by faecal attack when you come upon it unexpectedly as you walk in the park. The driver who stops at a pedestrian crossing captures and mitigates your destructive fantasies, as an observer, by alloying them with goodness. The protective object that is created by the driver and the car that is stopping can be introjected as part of a protective superego. Countless fantasies of this sort, worked back and forth between individual internal worlds and the collectively sustained social matrix, compose "society" as a collective imaginative effort.

In this process, society is held together as a stable object by a group illusion of its adequacy. This group object will comprise the variegated forms of fantasy found in individual object relating. In its rule-bound limitation of aggressive fantasies, it might have a paternal form; in its containing damaged buildings or flowerbeds, it might represent the inside of mother's body. In the multiplicity of fantasies, different for different people, a relatively neutral and stable setting for public life is maintained through collective imagination.

It is precisely that neutral stable setting, maintained by the complex of individual efforts, which is undermined by direct action. In its place, a torrent of primitive fantasy of a relatively homogeneous sort is released: a return of the repressed on a social scale. Meat eaters are meant to feel that they murder protestors who are identified with animals, which justifies murderousness towards them. The dramatic moment—concern for animals in a demonstration—might bring guilt and depressive anxiety about the state of society to a head. First, however, it becomes a paranoid moment, as concern becomes guilt, and guilt becomes a fear of persecution, which is projected in a dramatised

handing-on, as splitting is enhanced. The outcome of such a schismatic moment depends on the assimilation of bad objects.

Society continuously assimilates and represses primal fantasies; direct action mobilises them. Once mobilised, they have either to be reassimilated or discharged, in order not to produce apocalyptic delusions. Direct action eclipses the complexity of the social transactions that maintain society by forcing the audience either to assimilate its depressive side or, if it cannot be pressed in that direction, to persist schismatically to identify with either the victim or the tyrant. The immediacy of direct action short-circuits the psychic work that has to be done to maintain society. The dramatic moment confronts an audience, not so much with an immediate threat as with a mimetic enactment of an injustice that mobilises its unconscious fantasies. Because there are no other views, no debate, no psychic work to maintain the society, such a mimetic enactment confronts the audience *at that moment* with a delusional moment in which it faces its own unconscious. The neutral stability of the public space is foreclosed.

The neutral stability of the public space is an abstraction of the good object. It is produced by the assimilation of countless bad objects in transactions similar to those just described. Direct action is simply a dramatic—indeed, an intentionally dramatised—moment in the process of threatening and rebuilding a secure object-world. "Society" is one resolution of this psychic work, representing our awareness of a neutral public space, sustained by collective effort and abstracted into the machinery of the state. Typically, we highlight the distinction between the psychic processes of degradation and repair, on the one hand, and the neutral public space, on the other, in differentiating between culture and society. It is the difference between a matrix of psychic processes in their open interaction with the external world and relatively stable structures into which the psychosocial world settles.

In confronting an audience with its own unconscious, the immediacy of direct action creates a pressure to reduce the complex matrix of society to a polarity between victim and perpetrator. Since the anxiety that is being avoided is depressive, we can say that it reduces the complex matrix of society to a schism between damaged and mutilated objects, on the one hand, and a tyrannical structure that offers protection against depressive anxiety, on the other.

At the same time, the return of damaged and mutilated objects in this dramatic moment presses society to assimilate and repair them.

The making good of an injustice, at a conscious level, works, at an unconscious level, to restore the internal worlds of the members of society and, through re-projection and reintrojection, to promote cycles of restorative work to the social matrix and to the physical environment.

Material deprivations, whether it is of clean air in Greenwich, or of the countryside about to be paved, or on behalf of the animals about to be exported, are not in themselves the cause of direct action, but the ejection of depressive anxiety into a social sector burdened with damaged objects evokes a return of the repressed. In the terms of our analysis, the ensuing dramatic confrontation will either push them back into society and re-establish its legitimacy through their assimilation or it will intensify the schism and provoke a counter-attack.

Conclusion: the internal world of the material world

Direct action, in its dramatic intensity, breaks into society; it is different only in degree from the sudden, even though expected, appearance of the scene at the brow of the hill, which irrupted into the visual field and the mind of the boy on his way home. Let us draw these two vignettes and their associated analyses together.

The first example emphasises the comforting effect of the material reality of the streetlights; the second example introduces a formulation apparently not present in the first: the extent to which the containing adequacy of the societal object is illusory. Together, they bring out a dilemma. If the secure external object is the consequence of a purely imaginary effort, a cycle of exchange beginning with an outward projection of the containing function, then it is more vulnerable than if it rests on the materiality of the social world (though we could argue that the human capacity for imaginative containment is more reliable than an electricity network). If it can deal only with the known, and not with the spontaneous, it is limited and brittle, especially when the spontaneous irruption is of the virulently bad, as in the case of the dead and damaged objects described above.

There are two potentially divergent visions of the psychic meaning of society here. One, characteristic of a Winnicottian approach, is of the social order as fundamentally benign and adequate—"good enough"; the other is of a flawed society, possibly deceptive, certainly

needing continuous rebuilding. The latter vision is continuous with that of Freud (for example, in *Civilization and its Discontents* (1930a)), though there is, in Freud, an ambivalence towards society and one can find in his thinking a hopefulness for the development of a more civilised society, for example, in his essay "On transience" (1916a) and in his letter to Albert Einstein (1933b).

Yet, is the ambivalence to be resolved by a simple movement towards a positive vision of the social? The richest contribution of psychoanalysis to the social sciences, and to intellectual life generally, is more likely to be in its unsettling effects, in its perpetual search for the hidden and whatever is contrary to appearances. At the same time, psychoanalysis is a prolific source of images of hope and a basis for the appreciation of the resilience and creativity of ordinary person-hood and of ordinary society.

We come back to the beginning. We began with the idea of working from two poignant, but ordinary experiences, infusing the every-day with psychoanalytic thinking, hoping to enrich it, not to force it into a mould, seeing whether a thread pulls the disparate into a common theme.

The polarity between the reality of the external object and its nurturing function, on the one hand, and the lodging of an internal object in the external world, on the other, is a key feature of psycho-analysis. The significance and dynamics of this process might vary, but one strand, well represented by Winnicott and Klein, stresses the need to protect the internal world. We have concentrated on the need to establish a containing relationship to the external world. In addi-tion, we have seen the "containing matrix of the social" in the geo-graphical, physical, cultural, social, and political location of everyday experience. As a rough generalisation, we would say that the exten-sion of this polarity to social thought differentiates sociology and social psychology from psychoanalysis. However, it also suggests that we look at these alternatives as a dialectic and not a polarity. From that point of view, the external world is not simply something to which we submit or about which we have subjective personal responses, but neither is the subjective internal world the authorial agent of every-thing it perceives.

The salient feature of the streetlights was that they were not only material objects, they were also made by us; just as clearly as they were points of light, like stars, they were not stars; just as they

signalled home, they were not home; just as they evoked a sensory memory of mother, they were not even animate. The salient feature of the street protest was that it was not only an enactment of cruelty, it was just a group of ordinary people; just as clearly as we were all caught up in a moment in which we were pushed towards schismatic identifications with tyrant or victim, we were just shoppers; just as clearly as we were to think of ourselves as helpless lambs, we were sentient human beings provisioning our lives and those close to us. In both cases, we joined into a scenario on the spot, without rehearsal or preparation, and in the tension of that moment, the unthought order of social life resolved into a dialectic between an emotionally charged internal world and the facticity of the external world.

Both situations, though one involved inanimate streetlights and the other people demonstrating, were abstract. Each was distant from the experience for which it stood in a way that characterises modern society. Neither was grounded in face-to-face interaction, or in a ritual shared by all the participating members, or in a family or kinship unit; certainly not in a familial relationship or any relationship near to one. In each case, we have to interpose a notion of "society" between the subject and the figure to whom the subject relates. In the first case, it might be a comforting mother, in the second, an authoritarian father, but only a highly structured, abstract bureaucracy could have stood in for the primal object, whether streetlights in a patterned array or laws and a transport system.

The substitution of an abstract object for one closer to home has, in Lasch's (1979) analysis, pushed us into more primitive, pre-oedipal, object relating. The Frankfurt School (e.g., Marcuse, 1955) has argued a similar point, stressing the rage that boils up and remains unmitigated by the impersonal bureaucracy that has replaced the personal father. The pattern of streetlights, which comforted a young boy, was not designed to symbolise a mother. They amalgamate—in a distinctively modern way—an artificial impression and a natural comfort: linear arrays of glowing hot metal filaments in glass bubbles. The street protest aims to subject its audience to an emotional "mechanism", which pulls its spectators in the way the lambs are pulled systematically to slaughter. In both vignettes, there is a dissonant, jarring amalgamation of the human and the artificial.

We are drawn to a psychoanalytic cultural analysis based on the idea that artefacts can be analysed as external objects in relation to

internal objects: not just as repositories of internal objects, used in cycles of projection and introjection to bring order and peace to the internal world, and not just as material facts, reassuring in their materiality, but as both products and producers of an internal world. These cultural artefacts are made without any symbolic, ritual, or artistic intention: in our examples, streetlights and the routine slaughter of animals. Therefore, they bring the apparent confrontation between material reality and subjective reality to a head. We discover that we are never sure what we make and what we perceive as materially other.

Although we might scare ourselves with nightmares of a future in which fantasy mixes indistinguishably with external reality, we have also opened up a new dimension of social analysis, in which the "internal" structure of the external world can be investigated: the structure then resonates with the internal world of the subject. This form of connnectedness between internal and external, animate and inanimate, is modern. The nightmare is expressed in science fiction and in Kafka; the hopeful side has yet to be explored.

The therapeutic culture hypothesis*

The therapeutic sensibility

This chapter offers an account of a dimension of contemporary cultural change which, while familiar in many of its aspects, has not been described or theorised in the systematic way which we propose here. While there are a number of accounts of how a process of emotionalisation is occurring in various spheres, we seek to go beyond these to the hypothesis that there is a specifically "therapeutic" quality (in a particular and broad sense of the word) to emotionalised modes of self-experience and of identity. We propose the "therapeutic culture hypothesis", according to which most contemporary identities are therapeutically inflected, coloured by, and, in some cases, organised around a therapeutic sensibility.

There are three key core elements to this therapeutic sensibility: expressivity, knowledge, and compassion. These can be thought of as loosely corresponding to the Freudian triptych of id, ego, and super-

* This chapter is a slightly revised version of a paper, co-written in 2002 with Joanne Brown, which first appeared in T. Johansson and O. Sernhede (Eds.), *Lifestyle, Desire and Politics* (pp. 97–114). Gothenburg: Daidalos.

ego. When not cast in the reified form which psychoanalysis has sometimes allowed them to be, these categories have a richness and salience for many aspects of our culture that has not yet been fully explored. To some extent, we can map the stage of development of therapeutic culture using these elements. Any one of them might conceivably be present as a single cultural trait, though in combination they will strengthen and modulate each other, and the extent to which a therapeutic culture has become established, both inside and outside its formal institutional presence in the therapeutic professions, can be measured by the extent to which all three elements are present. That is, a culture of emotional expressivity, without thought (ego) or concern (superego) is not indicative of a therapeutic sensibility, which combines all three features. To bring in a Kleinian dimension, we could say that the presence of the reparative impulse is a hallmark of therapeutic culture, and is the likely result of feeling being conjoined with thought and conscience.

As a rough assessment, we could propose that contemporary British culture now enjoys a good measure of expressivity, that compassionate tendencies are gathering some strength, and are not as attenuated as they were feared to be during the Tory government of the 1980s and 1990s, and that potentially powerful resources of self-understanding are developing, though, as yet, only in pockets of the culture.

Therapeutic culture is a polyvalent development. It is a profound resource for the building of more civilised and compassionate institutions and social practices, and for the enhancement of individual autonomy and fulfilment, as envisaged by some of the more optimistic theorists of "postmodern" society. At the same time, it can give shelter to sentimentalism or more malign forms of irrationalism. The balance between these divergent values within the therapeutic is continually negotiated in the debates and conflicts in the therapeutic world, and also in the interactions between the therapeutic and other dimensions of our culture. The therapeutic is but one, though an important one, of a number of ways in which we can describe the contemporary world, and the trends which it embodies are set in a global field of forces—economic and material as well as cultural—operating at various levels and in various directions. Therapeutic culture may become a reality, but it is not free to extend itself without challenge from other social forces, and its development is shaped from without as well as within.

Definitions and categories

A component of the therapeutic culture hypothesis is the emotionalisation hypothesis, that is, the proposition that there is a current trend towards greater emotional expressivity and a generally increasing affectivity in everyday life. A particular model of emotions and their origins informs this chapter and its particular presentation of the emotionalisation hypothesis, which is a socio-psychoanalytic model. This argues for a complex interaction between our biological inheritance, its psychological elaboration, and the social scripts of emotion that await us. It posits a close developmental relationship between emotions and identity. It is a universalist theory which sees emotions as generated in the inner lives of individuals, on the basis of needs for certain kinds of experience (e.g., for bodily satisfactions, for protective containment).

This occurs through processes that are largely unconscious, but by no means beyond the reach of society and history. Indeed, as Elias (1978, 1982) and others have shown, the crystallisation, expression, and management of emotions are profoundly shaped by socio-historical processes, and vary between cultures. In different socio-historical contexts, therefore, different kinds of individuals will be produced, but, from a psychoanalytic point of view, individuals are, none the less, fundamentally constituted by enduring configurations of feeling (anxiety, love, aggression) with which they respond to the world. This chapter, however, is mainly concerned with drawing a link between late modern forms and discourses of affectivity and the therapeutic sensibility, rather than with defining and clarifying the possibilities for a psychoanalytic sociology of emotion (see Brown, 2000, for an elaboration of the latter).

In any case, the emotionalisation hypothesis, at least in its simplest form, is not necessarily tied to any specific psychological theory of affect. The definition of "emotion" which underlies the emotionalisation hypothesis is an everyday one. It refers to a very broad range of mental states, which can also be generically termed "affects", "feelings", "moods", "passions", and "sentiments". While a satisfactory general definition of this broad category is hard to find, it can be substantively defined by listing particular examples, such as love, anger, hostility, anxiety, envy, jealousy, and pity (though many of these are themselves broad or multiple categories). Simple dictionary

definitions sometimes tend to be *negative*, as when they define emotion as that in mental life which is not rational, for example, the *Concise Oxford*'s "... feeling as opposed to reason". In that emotion could be thought of as everything in the mind that is not cognitive or intellective, there is a truth in these negative definitions, though their choosing to foreground rational intellect and to see emotion as the residual category also reflects the rationalist traditions of Western thought. According to the emotionalisation hypothesis, this traditional suspicion of emotion is weakening, and so the emphases in dictionary definitions should change.

Moreover, the emotional expressivity posited here does not split emotion from reason, because the therapeutic sensibility links this emotional expressivity to the ability to think and talk about what we feel. Hence, emotional literacy and emotional intelligence (Goleman, 1996; Salovey & Sluyter, 1997) need to be distinguished from emotional expressivity. As Freud noted (1911b, p. 217), it is the "restraint on motor discharge which leads to thinking" and emotional literacy is not, therefore, the same as emotional release. Indeed, emotional intelligence, literacy, or learning must involve an acknowledgement of external reality and the ability to postpone emotional expressivity accordingly. An exclusively defined culture of emotional expressivity could be one that is only based on Freud's pleasure principle, in which "disappointment" (see Craib, 1994) or the postponement of satisfaction is not tolerated. This would mean that we live in a culture that encourages the repression of a knowledge of "reality" (others) when it disturbs our need for immediate gratification. It is, therefore, the setting up of the reality principle that ties emotional expressivity to an ethics of self-knowledge, because the reality ego safeguards the pleasure ego (our need for psychical rest, tension release), without losing contact with reality (our dependency on, and relationship with, others).

The second core element of the therapeutic sensibility (knowledge) is, therefore, a knowledge that is based on a relational view of the self. When mobilised, these values concerning expressivity and self-knowledge underpin, or give shape to, the third element, which is the key moral quality, or, at least, moral potential, of therapeutic culture: the strength within it of the reparative impulse.

The emotionalisation hypothesis proposes that we are living through a period in which the historic splits between the public and

private and between reason and passion are being reconfigured and, to some extent, dissolved as a consequence of a transformation in the relationship of affective life to public culture. In short, we are witnessing a profound emotionalisation of social life, led by, and in the domain of, popular culture but reaching out, like popular culture itself, into commercial culture (into business organisation as well as marketing), into political culture, and into personal life.

Emotions and their recognition, expression, and management have become an accepted and often required part of the everyday functioning of people as employees, citizens, and private individuals. Of course, the private domain has traditionally been the domain of emotional life, but, in recent decades, the minimum and maximum limits on what is regarded as desirable or as necessary in the explicit management of emotions have been pushed outwards. Caution has been reconceptualised as inhibition, and diffidence as withholding. While an outward style of emotional reserve is still perfectly permissible, it must now be framed by an assertion of self-knowledge and must ideally be an elective condition, subject to being overridden by a situational need for expressivity. In Freud's terms (1911b, p. 221), this would mean that "a momentary pleasure, uncertain in its results is given up, but only in order to gain along the new path an assured pleasure at a later time". That is, the substitution of the reality principle for the pleasure principle represents the safeguarding of the pleasure principle (e.g., emotional release) rather than the deposing of it (e.g., emotional inhibition). The reality ego or therapeutic self is, therefore, a model of containment and this ideal to which we might be encouraged to aspire, can, of course, be both therapeutic and/or inhibiting. The positive connotation of an exclusive culture of emotional expressivity is that it suggests spontaneous feeling, rather than a more restrictive management of emotion.

Emotionalisation and social theory

The emotionalisation hypothesis can be presented in some theoretical terms from classic sociology. Considering it from the viewpoint of Weber's typology of social action (Gerth & Mills, 1970), the hypothesis suggests that social action with an "affectual" orientation is becoming more prevalent, and also that there is an increasingly emotional

dimension to the other types that Weber described (rational and traditional). Emotionalisation can, thus, play a dual role in relation to the vitality and relative balance of different types of action; it might, for example, contribute both to de-traditionalisation, by generating new modes of social action outside the reach of traditional habituation (e.g., much of the expressivity and disinhibition now regarded as quite acceptable in British culture), and also to the re-energising of some traditional types (e.g., in the new, emotionally engaged styles of worship in some Christian churches). Weber's definition of action with an affectual orientation as determined by the *specific* affects and states of feeling of the actor points to the *individualised* dimension of an emotionalised culture, while his concept of the charismatic leader, one whose authority is based on an emotional commitment by followers, stresses the importance of the *personality* of the leader in an affectively charged society. At the same time, the notion of a charismatic leader with a mass following reminds us of the potential for *collective* processes linked to emotionality.

Another well-known typology to which the hypothesis directly relates, again concerning types of social action, is Parsons' "pattern variables" governing social interaction. These dichotomous variables are seen as presenting us as social actors with a choice between two modes of orientation to others. One of them is affectivity *vs.* affective neutrality (Parsons, 1951). The emotionalisation hypothesis predicts that patterns are changing, in that there is an increasing tendency to draw on, rather than to ignore, emotional commitments in our social relationships, so that there is a growth in affective relative to affectively neutral interactions. It would, thus, predict, for example, that the interactive styles in the workplace described by Hochschild (1983) as "emotional labour" would be increasing in frequency and importance (though the hypothesis would not imply that these necessarily involve the quality of alienation attributed to such work by Hochschild).

It would also predict that outside the workplace, as we discuss later on, there is a widening appreciation of the necessity and nature of emotional work in personal relationships. The terms "emotional *work*" and "emotional *labour*" (sometimes defined as the paid forms of emotional work) are apt, because recognising the emotional commitments in our social and personal relationships involves effort. According to Freud (1911b), the reality ego recognises that "real satisfaction

calls for effort and postponement (longing, deprivation)", hence the cathartic release of feeling is not emotional work.

The importance now attached, in practice in diverse fields, to issues concerning the emotions and their expression is matched by the increasing recognition of emotion as a key phenomenon in many fields of social and psychological thought. 1975 can be seen as the watershed year in which a distinct body of work began to take shape in the sociology of emotions (Wiliams & Bendelow, 1998) and the sociological trends identified below can be said to have informed its emergence. Moreover, these trends have challenged the disciplinary split between psychology (the individual) and sociology (society), the strict demarcation of the personal and the political and the terms of modernity in which reason is split from emotion, mind from body, and the subject from the object. (The following argument is developed more fully in Brown, 2000.)

First, for example, we can see that sociology would have been obliged to rethink its neglect of emotion, due to the very psychologisation of everyday life documented by, *inter alia*, Rose (1990), Foucault (1990), and Sennett (1993). Indeed, Rieff's (1987) "triumph of the therapeutic" refers to the growth of psychological discourses which we can see as sociological facts in need of theorisation. More generally, psychosocial theorists (Fromm, 1976; Lasch, 1984; Marcuse, 1969) were looking at the psychological effects of consumer capitalism and at individual symptomatology in the conditions of late modernity. It is, therefore, no surprise to see that Hochschild's book *The Managed Heart* (1983) is referred to as a "landmark text" in the sociology of emotions (Williams & Bendelow, 1998), because it looks at the way in which people will be increasingly used for their emotional labours in a promotional, consumer-based economy.

Second, what we also see in this period is the popularisation of the idea that the personal is political (second wave feminism) and the feminist challenge to the "categorical split between reason and nature which establishes the terms of modernity" (Seidler, 1998, p. 194). Indeed, according to Benjamin (1988) the principles of western rationality are based on masculine traits (separation, control, autonomy), which represent a "psychic repudiation of femininity" (interdependence, intersubjectivity). Moreover, feminist calls for emancipation meant that the question of equal rights "no longer came to a halt around our private lives" (Beck & Beck-Gernsheim, 1995, p. 2). This,

in turn, is one of the factors that has catalysed a process of de-traditionalisation which is transforming intimacy in gender relations, family structures, sexuality, and emotional expression. This is another instance of a sociological fact that has obliged sociologists to extend their analyses of inequality to the private realm of relationships (Giddens, 1992).

Finally, the postmodern challenge to Cartesian rationalism and Enlightenment "truths" (Derrida, 1972; Lyotard, 1984) has led to what Denzin (1989) calls a reconfiguration in the social sciences more generally. Hence, the "crises of the self" (Frosh, 1991; Richards, 1989; Woodward, 1997) of late modernity have been matched by "disciplinary crises" in which postmodern critiques of "the modernist epistemological project' (Usher, 1997) have obliged disciplines like sociology and psychology to review their own disciplinary boundaries. In both sociology and psychology, for example, the individual–society dualism has led to a neglect of either history (psychology) or of embodied feeling (sociology).

Williams and Bendelow (1998), for example, explain that the emotions had traditionally been banished to the margins of sociological thought, because the discipline had not attempted to rethink the relationship between knowledge and emotion. Emotions, they say, were generally treated as asocial and as somehow inhering in the individual. This meant that the social world was known through a "disembodied Cartesian conception of reason", which Seidler (1998, p. 194) explains led to a disdain for that which was personal/emotional. It is for this reason that Bertilsson, in 1985, concluded that "love's labours had been lost in social theory", arguing that the emotions had been treated in an instrumental and functional way. It is perhaps unsurprising, therefore, to find that the contemporary work on the sociology of emotion promises an "ontological commitment to different ways of knowing" (p. viii), and a challenge to Cartesian rationalism, and that the "emotions have come of age" in sociology (Williams & Bendelow, 1998, p. xxvi).

The "emotionalisation hypothesis", while being an attempt in social theory to articulate a new development in the world, is also, to some degree, the expression of a paradigm shift, a turn to affect in academic discourse that belatedly brings theory into closer conformity with what has always been the case in the real world, where emotion has always mattered. Of course, paradigm shifts and changes

in the object of study are, anyway, likely to be closely and complexly linked.

There is a parallel here with the rise of consumption as an agenda, and as a broad paradigm in social theory in the 1980s. To some extent, this was academic social commentary cottoning on to something which others had long known about but which decades of high liberal, and then Marxist, influence had systematically repressed in academia: the importance of consumption in culture and in the mind. However, it was also, and predominantly, a reflection of a real change in the constitution of society. There were new modes of cultural being and new states of mind, which de-industrialisation and de-tradition-alisation had brought forth. Marketing was an increasingly potent cultural force, and our relationships with commodities were increasingly complex and generative dimensions of our inner lives. The focus on consumption understood this, and sought to establish the relations of consumption as central ground in social theory. Similarly, the focus on emotion seeks to establish that the vicissitudes of emotional life, already glimpsed in the individual as consumer, are fundamental to understanding the contemporary world. There is not only an analogy between consumption and emotionalisation, but also an historical and intrinsic link. As almost every marketing philosophy knows, the consuming self is an emotional self, driven by desire, anxiety, and hope.

So, to some degree, the emotionalisation hypothesis is a necessary extension of the rise of consumption studies. There is not, however, a similar necessary link between consumption and the development of therapeutic culture. That is, although acts of consumption can be therapeutic, it cannot be said that the consuming self is necessarily a therapeutic self; at least, not unless guided by an ethic of consumption that reflected an emotional engagement with the issues of globalisation, justice and sustainability.

Nevertheless, there is abundant commentary that links the development of consumer society with the development of more explicitly emotional modes of experience and of relating to the world. Campbell's influential analysis of consumerism (1987) sees it as having originated in strands of Protestant thought and practice which stressed the importance of the inner world of feeling and its virtuous deployment in the outer world; feelings were a sign of the godliness inside. This attitude fed into the Romantic advocacy of passion and self-expression in the nineteenth century, and Campbell argues that this, in turn,

via bohemianism, provided the main psychological driver for consumerism. The bohemian Romantic, like the consumer, is in search of the new and the complete satisfaction; although this never arrives, it requires the individual to engage in a constant monitoring of experience and encourages a preoccupation with feeling. We might qualify this by noting that the consumer, although perhaps led to a reflexive engagement with their desires and their responsibilities, might not stand outside of their culture and reflect on it and its effect on them in the way that the bohemian outlook might suggest. Also, the Romantic is in search of the sublime, and, without denying the obvious pleasure shopping can bring, it might not be unreasonable to suggest that it does not always offer this experience. Nevertheless, some of the most basic elements of emotionalisation can, in this context, be seen to have roots extending back far beyond those last few decades in which the culture of the expressive has come to have a more complete presence.

The same conclusion is to be drawn from other analyses of psychosocial change in the work of the historians of emotional life, Gay (1986) and Zeldin (1994). Neither is directly concerned with developing a thesis about the place of emotion in contemporary culture, but both trace the earlier development of a reflective discourse of emotional life and relationships and see it as an enhancement of human experience. Indeed, Zeldin implicitly links the emotionalisation process to the art of conversation, in which we use words to reach out to (rather than bully, for example) another. Zeldin says that the ideal of the salons of the eighteenth century was to use words to "help feelings pass into the soul of others". If the emotionalisation process is a conversational phenomenon, it is, therefore, linked to a process of democratisation, because "it no longer mattered how rich, or how well born, or how physically beautiful one was, provided one know how to take part in conversation" (Zeldin, 1994, p. 35). That is, emotional learning and expressivity is not guaranteed by academic learning and/or by being intellectually articulate.

Viewed from another angle, the emotionalisation hypothesis is a particular version of the postmodernity thesis, being especially close to those accounts of recent social change which foreground subjectivity and identity (see below), and the increasing fluidity of self-experience. This brings us to a simple, but major, question: is the increased prominence of emotion a good or a bad thing? Is it a cultural enrichment,

enhancing the autonomy and fulfilment of individuals, or a culture of fakery and narcissism? This question is in need of rather more finesse in how it is posed, and, indeed, it is necessary to develop more specific forms of the emotionalisation hypothesis in order to answer it. We have so far posited a hypothesis which links emotionality with thought rather than sentimentality or artifice and, in order to look at whether a therapeutic sensibility is emerging, we would have to think about how (methodologically) to distinguish an id-type emotionality from thoughtful feeling.

Another way to approach this question is to ask whether we can see the emergence of a more emotionalised culture in relation to the civilising process. Elias (1978, 1982), for example, described the development over centuries of what he called the "civilising process", the gradual internalisation by individuals of ever more subtle and far-reaching constraints on their behaviour. As the increasing socioeconomic division of labour has brought us all into increasing interdependence, the need to regulate our aggressive and sexual impulses and bodily functions and habits so as not to harm or offend others has become ever greater. Over the centuries, codes of conduct and the demands of civility have, therefore, become ever more stringent.

It is a criticism of Eliasian theory that it cannot deal with the postmodern world of permissiveness and emotional deregulation, in which the main trend seems to be the dismantling of some social controls and a loosening of restraints. Elias had, however, begun to develop a response to this criticism. He pointed out that the increasing fluidity of social roles and the dissolution of many conventions require the individual to be ever more self-reliant in deciding upon appropriate courses of action. In the absence of traditional or consensual restraints we have to fall back on our personal, individual resources more in deciding on what is the best way to conduct ourselves. What this means, Elias suggested, is that we are becoming yet more self-regulating and, therefore, that the core of the civilising process—which consists of the internalisation of controls and regulations—is still being carried forward. He notes that the previous external constraints were particularly to the disadvantage of women.

However, it could be argued that the values of an emotionalised culture offer an amelioration of the rigours of the civilising process for the individual; they provide spaces to reflect upon its controls and the demands they make upon us. In sport, it might function as a safety

valve, in allowing us to relax them, albeit in particular and controlled ways. However, more fundamentally, it might be a continuation of the civilising process, a new phase in it, since it could exhort us to be yet more mindful of the needs and sensibilities of others, and to develop more sophisticated and effective ways of managing our own emotional lives. Notably, Phillips (1995) warns us of the "civilising" tendencies of psychoanalysis, and it must be noted that the therapeutic sensibility, for example, could equally become one that we might need release or relief from in its moral prescriptiveness.

So, let us suppose for the time being that the civilising process thesis holds, and is arguably enriched by its explanation of emotionalisation, which requires us to understand that, in the field of emotions and their expression, regulation does not necessarily entail restraint or suppression. The recognition of economic interdependence led to the growth of civility and restraints upon aggression; now, as both the depth of human interdependence and the recognition of it increases, and as our confidence in the civilised behaviours already achieved increases, the civilising process extends into further areas of life and further into the subject, and yields more complex modes of regulation. It delegates emotional regulation to the emotional subject, thus risking anomie; if, however, the subject recognises the task and takes it on, she or he can utilise the growing cultural supports available for undertaking it. We are, of course, surrounded (and penetrated) by normative discourses regarding appropriate or mature emotional responses or dispositions and there is something at least potentially sinister in this growth of emotional self-government, as Foucault and others have suggested.

However, it can be seen, as Elias does the whole civilising process, as a broadly positive development, an advance in the human condition.

Moreover, there are important parallels between the civilising process and the development of consumer societies and consumer cultures. In many respects, the growth of mass markets and the democratising of consumption can be seen as a civilising influence in Elias's sense, as learning to use or consume many consumer goods has involved more attention to hygienic or aesthetic considerations or to the opinions and feelings of others. Nevertheless, it is possible to engage with, or anticipate, the feelings of others (their admiration of us) in largely narcissistic terms. Hence, the same convergence in therapeutic space between civility and consumption can also be seen from

more critical perspectives. The consumer might be seen as led into a "therapeutic" discourse by the illusory embedding of consumer goods in affect, so that goods become fetishised emotions, while this therapeutic project of the consuming self can also be viewed as the further colonising of the individual by the regulatory intrusiveness of the civilising process, demanding more and more attention to the nuances of social judgement.

The components of therapeutic culture

To the emotionalisation hypothesis, with its core postulate that there has been a significant "affective turn", we wish to add the contention that the present preoccupation with feelings is cast in a uniquely late modern way, as a preoccupation with the therapeutic potential of engaging with, and seeking to manage, emotional life. The terms "therapeutic" and "manage" are used here in a neutral way, implying neither unproblematic ideals of cure and autonomy nor sinister projects of governance and control. This is the therapeutic culture (TC) hypothesis.

However, few theorists of social change since Rieff have given a central place to the coming of the therapeutic. There are, none the less, some other attempts to look beyond or behind the polyvalent profusion of counsellings and therapies with the idea of finding a single, elementary, but coherent, language of values. The work of Rose, especially in his book *Governing the Soul* (1990), was an attempt to do something similar, though using a different approach based on the ideas of Foucault. Scholars in the tradition of Foucault, while eschewing an explicit, simple evaluation of what they describe, none the less often convey that what they are describing is a massively sinister development. The approach taken here seeks neither to decry nor idealise the development of therapeutic culture, but overall is different from the Foucaultian one because it allows space for evaluation, in an "old-fashioned" humanist sense. It inclines to the view that the therapeutic is to be welcomed, as it carries great potential for increasing human wellbeing and creativity. TC is, though, a mixed development, requiring a complex assessment. So, the task is not to develop some overarching rhetoric about it, but to assess its practical effects and possibilities in specific social contexts.

Rieff argued (see, especially, his *The Triumph of the Therapeutic*, 1987) that the influence of Freud was producing a culture in which traditional authorities could no longer command allegiance, because, in the post-Freudian era, people could understand that their attachments to such authorities were likely to be based in their neuroses, in their defences and idealisations. Morality would, therefore, have to be derived in future from the examinations which individuals could make of their own inner worlds. At the time when Rieff was taking stock of the "therapeutic" (in the mid 1960s), it was possible to identify therapeutics with psychoanalysis. Several decades of huge and diverse growth later, we must set out a much broader and still more complex picture of what the "therapeutic" is, and of how it has triumphed, taking stock of the proliferation of therapeutic practices and theories of all sorts. While Rieff was basically correct in his observation that therapy was transforming the nature of authority, it is not the case that this was caused by Freudian insights. While we can see that psychoanalysis remains central in various ways to both the development of therapeutic culture and to understanding it, we need to place the development of the therapies, psychoanalytic and other, in the context of wider social forces and to see them embedded, as both causes and effects, in a complex of historical change.

The transition to TC is, therefore, one dimension of contemporary society, though it is a far-reaching one that extends beyond the growth of counselling and psychotherapy as specialist activities. It is necessary to describe its empirical forms, and to establish the extent to which the TC hypothesis does identify a demonstrable trend and a linked set of phenomena. Some of the characteristic features of TC are as follows. Some of them are background commonsense for those in, or familiar with, the specialist therapeutic world, but their wider influence as a broadly coherent set of values is now such that they represent a powerful cultural force.

In the following account, we will be ignoring the differences between the various schools in the worlds of therapy and counselling. In many circumstances, these differences are profound and crucial, such as those between psychoanalysis and humanistic psychology, on many issues of clinical technique and in underlying philosophy of human nature (see, e.g., Richards, 1989). However, at the most general levels of historical change it is possible to identify some underlying or

background values that might be common to most, if not all, forms of therapeutic discourse.

At a basic level, there is first (as any form of the emotionalisation hypothesis would assert) a wide preoccupation with feelings. The particular inflection given by the TC hypothesis to this basic general observation is that the preoccupation is also often with relationships, and with the interdependence between feelings and relationships. A substantial body of recent sociological writing has focused on changes in the nature of intimacy and in sexual love relationships. In the ideology of romantic love, intimacy always had a sort of therapeutic dimension in the salvations and cures sought in love. Now, however, in the sociological writings of Giddens (1992), Beck and Beck-Gernsheim (1995), and others, intimacy is described as having become a therapeutic space in a contemporary sense of therapeutic, as we are using the term. Giddens' framework is based on the assumption that there has been, and continues to be, a gendered division of emotional labour, such that women are the emotional specialists, and, as such, are taking a leading role in managing the transformation currently taking place in the nature of intimate relationships. This transformation is one in which the content and purpose of intimate sexual relationships is increasingly determined by individuals in terms of their own explicit life projects; that is, people are developing self-conscious narratives of who they are and what they want, and see relationships (like other areas of life) as an area of choices through which they can further the project of identity development. Giddens discusses this as a form of "reflexivity", since it involves reflecting on the meanings of one's life and the choices one faces, and using that reflection to shape the future. The "transformation of intimacy" that Giddens describes is a therapeutic transformation, and is a democratisation of emotional autonomy (see Brown, 2000, for a psychoanalytic critique of Giddens, 1992).

As evidence for this rudimentary feature of TC, we can adduce the high "therapeutic" content of popular culture today, in, for example, the content of television soap operas, the popularity of chat shows and "docu-dramas", the change in the nature of crime drama towards much more psychological narratives, and other aspects of media content. We could also describe this feature of TC as an intensified interest in the ordinary and the everyday, based on an awareness of the emotional depth and complexity of the ordinary.

This rudimentary value, involving sustained attention to feelings and relationships, means that, at least in implicit ways, the experience of the self is brought into a central position. There is a link here between TC and a leading idea of our age, that of identity. "Therapeutic culture" is "identity culture". The two terms are not equivalent, though, since identities are not only personal, but cultural and political, and the "politics of identity" can be about impersonal categories and non-therapeutic values. There is, however, a close link between the rise of therapeutic values and that of notions of identity. Both are premised on the importance of reflexive self-experience, on our growing tendency to interrogate our experiences and to ask about the self to be found within them: what is this self, and where is it going? The importance of identity and its crises in contemporary experience is a major way in which the therapeutic project of the self has become integral to subjectivity, and is linked to more conventionally political agendas.

Next, there is the belief that the disclosure and exploration of feelings, particularly, but by no means only, in conversation with a professional, is therapeutic, both in preventative and curative modes. While this belief still has to compete with dismissals of such conversation as "just talk", the power of talking about feelings is often seen to be great, to the extent of having life-transforming potential. It is assumed that inside us all is a world of troubled feeling, of pain, conflict, or damage, and that to enter this world is a routine but crucial test of character. Moreover, some forms of this belief specify that, in certain relational contexts, such as conversations with partners or close friends, the disclosure of feelings is necessary for obtaining and for giving the most in such relationships.

However we judge it, how can the value of expressivity and its reflexive deployment in relationships and their negotiation be observed in social life? It is less amenable to tracking through the kind of quantitative measure of media content suggested for operationalising the more basic features of emotionalisation. This value has a long and complicated history in psychological thought, in theories of creativity and so on. It can, however, be tracked through studies of the advice or self-improvement literatures. We might predict that "pop" psychology from the late 1960s or early 1970s would show evidence of the making of the link between expressivity and health. We might, in particular, look for it in manuals and magazines for parents, in the

guidance given on how to respond to various kinds of emotional communication.

Alternatively, we could hypothesise that heroes and heroines of box-office hits, or of romantic novels, are increasingly defined or saved by their commitment to affective self-expression. Evidence could also be found in records of changes in the routine practice of the welfare professions, particularly in psychiatry and social work, where we might expect to see an increase from the 1960s onwards of encouragement to patients and clients to disclose and confront troubling or hidden areas of feeling. There are probably innumerable empirical windows on to this aspect of the therapeutic, which involves changes at the level of both professed values and ideals and at the level of everyday behaviours. The former can be assessed through documentary evidence of various sorts, while the latter can be studied through life-history work.

It might be useful here to note that the emotionalisation hypothesis, and, indeed, the therapeutic culture hypothesis as a whole, must take some account of the possibly different fates of different emotions. It is quite possible that some areas of emotional life are subject to changing social regulation in the directions suggested, towards more recognition, attention, and expression, while others are not, and might even be proceeding in a different direction (see, for example, the work of Yates (2000) on jealousy, which appears to have become less admissible even while emotionality as a whole has prospered). Indeed, Craib's (1994) *The Importance of Disappointment* would suggest that only emotions that are well managed are expressible. Hence his critique of Giddens' (1992) "pure relationship", which he sees as a model for the false self of late modernity. It is also important, of course, to draw attention to the fact that the disclosure of what we feel or think is potentially very risky and possibly hindered by unconscious fears about loss, rejection, madness, etc. Indeed, for some people, the interest in their psyche, relationship, or feelings might be threatening and/or, for other reasons, simply unwelcomed.

Moreover, a "culture of expression" might be one that erodes an inner reserve and/or capacity to sublimate (see Weatherill, 1997) which alerts us to the possibility that the erosion of boundaries can lead to increased levels of anxiety. That is, a culture that is more explicit, open, and de-repressed could be one which stimulates perverse elements of sexual excitement. Weatherill is particularly

interested in the excessive sexualisation of culture, but his invocation of Winnicott's (1965, p. 187) plea to respect a part of the patient that is "incommunicado" is equally relevant to discussions of emotionalisation and the therapeutic sensibility. Perhaps the fine balance between interaffective attunement (Stern, 1985) and the need for privacy is summed up in Winnicott's "it is joy to be hidden but disaster not to be found" (1965, p. 186). The therapeutic sensibility, we might hypothesise, would respect both.

The belief in the possibility of a therapeutic encounter consisting of talk about feelings is usually not just a belief that a certain kind of *process* is possible, and often desirable. There is another component to the "therapeutic attitude" here, commonly, if not necessarily, linked to the belief in talking about feelings. This is the belief that a certain kind of state is possible and desirable to achieve through the processes of talking and self-reflection, a state (or process) of self-knowledge. There are many words for this state in the languages of clinical work and its different theoretical traditions: terms such as resolution of the transference, insight, integration, self-actualisation, and the acceptance of internal reality are all relevant here.

Taken a step further, the belief in the value of self-knowledge can give rise to a further, distinct belief: that emotion is the fundamental *truth* of experience. Self-knowledge, defined as knowledge of one's feelings, is seen not just as a vital component of balanced and responsible selfhood, but as the only key with which to access the deepest kind of truth about oneself and one's life. Here, the therapeutic ethos can converge with old critiques of reason, of rationality, and of intellect, and, by extension, of post-Enlightenment modernity as a whole. However, once emotional expressivity is conjoined with self- (other) knowledge, it is not only a knowledge of what we *feel* that would be evident, but a particular form of self-reflection (or, in sociological terms, self-reflexivity). That is, it is not feeling *per se* which is central, but the way in which we narrate and reflexively order what we feel or have been feeling.

The impulse for emotionally attuned self-knowledge could merge with a religious ethos, save that the communion is not with God or one's fellow-worshippers, but with the primary sources of oneself— though we can be back on religious terrain if this primary inner being is construed theistically. However, therapeutic culture is not at heart a religious one. It might often have religious affiliations, and, as many

have pointed out, is a successor to religion, especially to confessional practices, but, in ideal type form, it is a secular phenomenon, in which elements of religion are bound into a modern space which does not *require* a spiritual presence.

What might be required here is a sort of Foucaultian enquiry into discourses and technologies of the self in the past few decades, but one in which affect is seen to subsume and replace sexuality as the site of "truth". This would give us insight into the beginnings of an emotionalisation process, but, as stated above, the therapeutic hypothesis would require there to be an increasing prevalence of narrative or reflexivity as examples of sublimated or contained emotion.

The hypothesis to be tested is that the true core of selfhood is increasingly believed to be in what one feels and thinks, not what one does. It is not, ultimately, your work or your achievements which define you, but what you feel and think about what you have done. It is not in your values or your possessions, but in what you feel, at the latest point in your life, about your parents, siblings, friends, partners, children, and yourself.

As stated in the Introduction, these values concerning emotional expressivity and self-knowledge underpin, or give shape to, one of the key moral qualities, or, at least, moral potentials, of therapeutic culture, which is the strength within it of the reparative impulse. The fullest or most direct expression of the rolling out of the reparative impulse across individual biographies and social institutions is to be seen in the increasing numbers of people being professionally involved in the provision of opportunity for truth-generating conversation. This is the most concrete manifestation of TC: the rapid growth of the therapeutic professions. As well as the huge increases in the numbers of specialist therapists and counsellors, we must also note that many other professions in a range of settings (e.g., teachers, health workers, and managers) are now guided in at least a part of their work by therapeutic values. In all, it is conceivable that over a million persons in the UK are now engaged, directly or indirectly, in therapeutic work.

A corollary of this very substantial position of therapeutic work in the national division of labour, and of the widening influence of therapeutic values, is that it will be widely assumed that therapeutic help is appropriate, even necessary, for people in a diverse range of difficult situations, extending far beyond those groups now conventionally

defined as needy recipients of counselling—the neurotic and depressed, and the traumatised of various kinds: the bereaved, victims of crime, the soon-to-be redundant, disaster survivors and witnesses, and so on. The new putative clientele includes many people previously either straightforwardly envied, or seen as in need of more traditional, disciplinary kinds of intervention: lottery winners, pop stars catapulted to fame, footballers with anger management problems, and so on.

Sometimes, the reach of the counselling ethos might seem excessive, or wrongly directed. However, the TC hypothesis neither endorses all new applications of therapeutic techniques nor implies that they are a matter for cynical comment. Each instance needs to be evaluated on its merits, and while some cases might be examples of professional imperialism, or of a naïve belief that cures can be slotted in where necessary, the trend overall is a positive one. It carries the possibility of strengthening our understanding and containment of the emotional dynamics in a host of social situations, and of bringing some support to many individuals in need of it.

People who carry the stamp of this culture most clearly, whom we might call therapeutic individuals (whether they actually are therapists, patients, or neither), want to make something better. They do so typically not in a spirit of adolescent idealism or millennarianism, of wanting to make the world better, but in a more pragmatic and focused way. They want to ease the pain or improve the quality of their own or others' emotional lives by exploring and managing feelings, by responding to distress, and attempting to repair damage.

A number of possible measures of the social strength of this impulse suggest themselves, changes over time in number of applicants for courses training in, or leading to, the welfare professions being one. Others outside of the educational context would be the level of charitable giving, and of voluntary work or fundraising activities. While some such measures might show fluctuations, and all would involve complex collations of information, we would expect them to show overall increases in reparation-based activity in recent decades. There have, though, been falls in levels of charitable giving in the past few years, which require careful analysis in relation to economic conditions.

The wider the acceptance of therapeutic values, the greater the authority with which therapeutic professionals will be able to speak,

as they are likely to be seen as having privileged access to desirable states of self-knowledge or, indeed, to the core meanings of life. We can, to some extent, see the proliferation of professional and *quasi-professional* therapeutic practices as the basis for another feature of therapeutic culture: the institutionalisation of compassion. Without offering a blanket endorsement of the beneficial nature of counselling and therapy in all contexts, we can say, as a generalisation, that the introduction of formal therapeutic roles such as on-site counsellors creates a structural opportunity for the exercise of compassion where there might not otherwise be one. Of course, therapeutic work is not definable simply as the exercise of compassion, but the nature of therapeutic technique is one thing, and the sociological meaning of therapy is another. In defining the latter, it is appropriate to see therapies as, in important part, an institutional expression of compassionate values; that is, of a constant empathic alertness to the suffering of the individual whatever their situation, and of a commitment to mitigating that suffering.

There is a second way in which we can expect to see an institutionalisation of compassion, distinct from the formalised presence in institutional contexts of therapeutic professionals, and that is in the development of national and organisational policies that are informed by an appreciation of emotional needs and the establishment of practices in all spheres of life that, wherever relevant and possible, embody therapeutic values. Many areas of social policy are the most obvious fields of governmental action where this is feasible; the organisation of work and, perhaps, the practices of management in all contexts, are major spheres in civil society where the values of expressivity, self-knowledge, and compassion might have widespread application. The interest of many therapists in the therapeutic potential of the arts indicates that cultural policy is another major region where the strength of a therapeutic ethos could be powerfully felt.

There is a risk, though, in putting this broadly positive conception of therapeutic practices into too sharp a relief in case that invites in a kind of millennarian zeal, as in the claim that cathartic relief is being brought to an anti-cathartic society. Can it really be argued in general terms that the "post-Diana" world is an anti-cathartic one? The debates about the nature of the public reaction to the death of Princess Diana are, of course, of great relevance to the TC hypothesis. They are debates about the nature of TC, and are also, in part, old debates about

the relation between reason and passion. For some critics (e.g., Anderson & Mullen, 1998), the world is "awash with sentimentality", and the values of TC are false, regressive, or degenerate. Although this criticism is often loose and splenetic, it raises important questions about how therapeutic values are being appropriated and disseminated.[1]

A footnote from late 2016

At the time of writing, the national news agenda is frequently led by the latest developments in British football's recently emerged scandal concerning the alleged sexual abuse of boys by professional coaches working for professional clubs, including some leading ones. A new set of "historic" child sexual abuse inquiries by the police is in train, following earlier ones this century which have focused on the Catholic Church, the Church of England, the BBC, and the Houses of Parliament. These excavations of perversity among the personnel of venerated institutions have loud but complex resonances in the public sphere, not the least of which is their contribution to the growing reservoirs of public contempt for nearly all forms of societal authority, as well as feeding the media appetite for "moral panics". It is, however, plausible to suggest that another trend to which they contribute is a therapeutic one: a readiness to face up to psychological disturbance, to acknowledge the emotional damage it caused, and to try to prevent any future collusion with it.

CHAPTER FOUR

Containment and compression: politics in the therapeutic age*

Political authority and containment

The 1990s newsworthiness of the "spin doctors" has long since faded. Some commentators might continue to find fascination in probing the skill base of this late modern "profession", or in speculating on the scale of its influence. However, for most of us, the spin doctors and their works are now an expected thread in the fabric of politics, and might even have resettled into the background of political life, where we are told they prefer to stay, though they might occasionally be extruded again on to the front pages.

This is probably as it should be. It would be an unhealthy political culture in which we were all constantly preoccupied with the micro-management of the impact of politicians upon the public. Yet, it would be wrong to assume that spin is no more than the narcissistic element in politics, regrettably inflated in this hyper-mediated age but really, in the long run, only a minor act on the grand stages of our public

* This chapter is a slightly revised version of an article titled "The real meaning of spin", which was published in 2000 in the journal *Soundings*, *14*: 161–170.

culture. Spin does, indeed, connect with the narcissistic tendencies that have a very long history in public life, but it also connects with particular modes of promotion and propaganda most developed in the marketing and advertising industries in recent years; these have a shorter history but a much longer future, in both commerce and politics. Spin is not a tasteless froth that can be skimmed off the "real" thing. It is part of a change at the heart of contemporary politics, a change in the nature of authority.

To understand authority today, we need to understand the idea of containment, an idea developed especially in post-Freudian psychoanalysis but finding application in a widening variety of contexts. It refers to the psychological importance of exchanges between people, or between people and social institutions, in which the anxieties of individuals are effectively managed. The process of containment requires, first, that the depth and nature of the anxiety is recognised and acknowledged by all parties in the transaction, and, second, that at least some of the people involved can confront and tolerate the anxiety. Their capacity to do so serves as a container for the anxiety and as a model for others. Anxieties that are recognised and tolerated are much less likely to distort judgement and to exert a negative influence on practical action in the world.

One feature of the present day is the increasing involvement of authorities of various kinds in the provision of containment. This therapeutic dimension to the exercise of authority has come about because we now inhabit a therapeutic culture, that is, a culture characterised by a high level of concern with, and investment in, emotional management. To a considerable extent, this is a work of *self*-management, since another feature of therapeutic culture is the fundamental importance attached to the self and its potential degree of autonomy. None the less, authorities are still needed, as sources of guidance and example for individuals in their tasks of emotional self-management. Indeed, as these tasks are more fully engaged with, their scale and complexity is such that the need for authoritative help increases. The sources of this help are often to be found in people and places we would not normally think of as being authorities in a more traditional sense of the word. For example, the work of containment by social institutions is now increasingly being carried by popular culture, especially by television drama, by the organisation of feeling around sport, and by popular music.

Positive and compelling images of authority are now of someone or something which can contain. Authority in the therapeutic age can be credible only if it has attuned itself to the anxieties of its subjects, if it is able to receive their anxious communications, and to demonstrate how to live with their fears. Thatcher and Reagan were perhaps the last examples in the west of full-blown pre-therapeutic authority.[1] In that passing mode, the tie of the subject to the leader was based not on containment, but on its opposite: on the shared denial of anxiety and need, and on the projection of unacknowledged feelings into others who were then attacked for their weakness or their difference.

Certain issues can bring the process of containment—or the lack of it—into sharp focus. In one of his less well-judged statements as Prime Minister, Tony Blair's insistence on one occasion that genetically modified foods were safe to eat, and that he was quite happy to eat them himself, completely failed to recognise the potential depth of public anxiety. Whatever health risks there might or might not be attached to GM foods, it has to be recognised that food can be a particularly sensitive topic in politics, as it can be in family life, because the infantile anxieties it can evoke will be very basic ones. A huge amount of trust is needed for the baby to feel that what it is being given to eat is good, and will not harm it, and when this trust falters, as it inevitably will at times, powerful fantasies of badness will be released. In its overall regulatory role in relation to agriculture and the food industry, the government perhaps comes closest to enacting the parental role in relation to the citizen-as-baby. Of course, the National Health Service is also a prime site for the evocation of images of parental care, which is one reason why it has become such an iconic political issue.

Blair's comments on GM foods echoed the earlier famous appearance of the Conservative minister John Gummer with daughter and beefburger at the height of anxiety about infection with a degenerative disease known as BSE ("mad cow disease") from the consumption of beef. That risked evoking fantasies of government as a crazed parent being prepared to sacrifice children to belief or self-interest, not images of a caring parent trying to understand and contain a child's anxieties, however groundless in reality they might be.

Notwithstanding this example of an uncontaining contribution to the debate about GM foods, the Labour government under Blair was more attuned than any other previous government to the new

importance of containment and to therapeutic authority. Indeed, this was what was new about "New" Labour, aside from any arguable novelty in the substantive policies of the "Third Way". What was new was an understanding that political authority must, henceforth, seek to connect itself with the popular, in the sense of seeking to identify and contain popular anxieties. One collateral strand in this was the much criticised "Cool Britannia" strategy, if it was one, of trying to link with the containing institutions of popular culture. In the late modern or therapeutic mode of emotional management, political authority must be popular, which is not to say that it will always stand in the position favoured by the majority, but that it is interwoven with popular culture and orientated to the recognition of popular fears and hopes.

This is the real meaning of "spin". Whatever the merits and demerits of the individuals best known for their practice of spin, the prominence of concerns with the "message" is an indication of the importance now seen to reside in managing the emotional dimensions of the political process. Like many other aspects of therapeutic culture, this importance has been gathering since the 1950s, and—again like other therapeutic features—was (for obvious reasons) closely linked to the emergence of television. The moving images of wars, poverty, and exclusion, and the fleshly presence of politicians in their inescapable personhood, which various screens now bring to us all, have helped to bring the political process into visibly close entanglement with the emotional life of the individual citizen.

The much-scorned so-called "focus group", that is, the use of discussion groups of ordinary people to explore public attitudes, is, in itself, a neutral technique, but is potentially a means by which popular feeling and anxiety can be explored and identified, with the results of that enquiry being fed back into the intensified management of communications and, therefore, potentially to the work of containment.

The message of the "spin doctors"—not whatever specific message they want people to stay with at a given moment, but the underlying message contained by their activities as a whole—is that authority has changed. You can shoot these messengers if you do not like them, but their underlying message will arrive in other ways. Spin, at its best, is the realisation that the exercise of political authority must involve containment. It cannot proceed purely on the bases of rational argument

about policy and the orderly contest of value systems. Spin is the real-isation that political choices, like others, are now embedded in emo-tional narratives, and that these narratives are negotiable and subject to continual revision as they circulate in the public domain and move back and forth for each of us between the external world of online newsfeeds, newspapers, television, conversation, and so on, and the internal world of anxiety, need, and phantasy. Like other aspects of emotional life in a therapeutic world, they can be studied and—up to a point—managed. At the present time, this function of political narrative management is carried by "spin doctors", which means it is located primarily in a poorly regarded cadre of specialists within the political class. This, though, need not be its permanent location; it could become more integrated with other aspects of the political process and no longer attract such specific and suspicious attention.

There is obviously another cultural trend operative here, alongside the therapeutic one. It is what the sociologist Wernick (1991) was one of the first to call promotional culture, the increasing involvement of all social institutions in the promotional techniques of the market-place. Spin is obviously about the promotional imperative when applied to politics, but the promotional imperative has to be under-stood in the context of therapeutic culture, because it is changes in culture outside of the marketplace that determine what is valued in the market, and many social values are now heavily influenced by the therapeutic ethos.

The compression of public figures

In addition to the value of containment, a second key principle of ther-apeutic culture is compression. I use this term to refer to the way in which, in late modern culture, any specific social location can embody different psychic elements. One institution, or person, can represent to us, for example, both desire and restraint, pleasure and authority. This is a major departure from the compartmentalisation of psychic func-tions between different parts of the social body, which is characteris-tic of the early modern period, when the carnivalesque of popular culture stood apart from the repressive institutions of church and state. There is now a compression of psychic functions at specific social locations: different, sometimes opposing, qualities are brought

together rather than being segregated into different social spaces and agencies. To call this "compression" enables us to link it with the concept of time and space compression used in the sociology of post-modernity. In an influential description of postmodern society, Harvey (1990) elaborated the concept of time and space compression. He argued that the development of modern transport and communication systems underpinned a radically altered experience of space and time, which lose their power to separate people and events and to maintain barriers and boundaries. In a similar way, and perhaps as a consequence of space–time compression, we can see a tendency for different psychic functions and agencies to be compressed and inter-mixed on the social stage.

An outstanding example to date of this sort of compression was Princess Diana. The public reaction to her death was one of the major mass psychological phenomena of our time, and there is much to understand in that complex and global wave of affect. Here, we pick out just one feature of her public self, albeit one which is central to understanding the nature of the social changes which she embodied. In her persona were compressed an array of libidinal values—glamour, wealth, hedonism, anorexic neediness, and so on, and a gathering of more superego related ones such as compassion, world citizenship, and parental responsibility. This fusion of values distinguishes Diana from an earlier icon with whom she was compared. Marilyn Monroe's meaning for the public was rooted solely in the sexuality and emotional hunger that she embodied, without any countervailing values that might have endowed her with some elements of authority.

This compression of contradictory values into one mediatised figure, as exemplified by Diana, is a process occurring in the public image rather than in the inner life of the individuals concerned, though where the values combined are in extreme tension, as was the case with Diana, there might be considerable stress experienced by the individual concerned. As well as considering famous individuals, we can also find examples of compression within trends in corporate imagery and institutional identity. Banks and building societies, once heavily clothed in images of prudent and restrictive authority, are now gaily bedecked with messages of pleasure and release, while also trying to retain some of the traditional functions of authority in the support and advice they proffer. In this, as in many other examples,

the compression can be seen to result from the increasing influence of consumer culture, drawing all sectors of life into its pleasure-orientated agendas, but it is important to note that the process is not one-directional: authority is not simply collapsing into pleasure. At the frontiers of consumer culture, in advertising, moral and political agendas are now inserted explicitly into commercial messages, as, for example, in advertisements for film, biscuits, phones, and clothes. While one may be sceptical of, for example, the contribution of such advertisements to the cultivation of global citizenship, the broad development of ethical consumerism is a substantial development that is having a major impact on marketing. It shows how consumerist hedonism is being tempered by its compression with moral discourse. In all these examples, from banks to Benetton, we see a compression of pleasure and responsibility, and a picture of how authority is being reconstituted in consumer culture.

There are other ways in which the domains of pleasure are being interwoven with elements of moral authority. Band Aid, for example, and the many similar ventures since, is a significant fusion of the libidinality of pop music with a rudimentary sense of global citizenship, of hedonism with a reparative wish. On many fronts, then, the sensual is becoming serious, and the serious is becoming sensual. Compression of other kinds of elements is transforming our society. Foremost among these would be the way in which, under the slogan of "integration", many kinds of disorder and disability have been brought into everyday life, as with efforts to include behaviourally challenging children or those with special needs in normal schools, and, most controversially, the strategy of returning the mentally ill to the "community". The general idea of the "community'" as an inclusive, diverse, and curative entity has put an agenda of compression at the centre of social policy.

Of course, in the case of Diana and in other individual cases, we could also note that there is a powerful narrative of *cure* at work, which is another feature of the therapeutic. These are people who are believed to have faced the demons inside themselves and overcome them. In the image of the damaged but recovered person there is both a central motif of therapeutic culture, and a key instance of compression. Images of vulnerability and resilience, and of pleasure and duty, are compressed into this kind of persona, which is becoming a prevalent type in present-day culture. While, on the face of it, we might

seem in some such cases to be dealing with purely charismatic quali-
ties, and a revival of simple and dangerous charismatic authority, the
compression of different psychic values into one persona means that,
in fact, more composite and complex forms of authority are being
developed.

Let us take these considerations and apply them to political
authority. When Ronald Reagan became President of the USA, this
could have been taken as a confirmation of the most anxious predic-
tions about the collapse of authority into its charismatic form, and the
resurgence of banal charisma. Here was an actual star of the screen,
albeit only B list, whose one political talent seemed to be in his ability
to promote himself as likeable, who was now the leader of the west-
ern world. But Reagan's sanitised image was too much artifice, and
too simple. He marked the end of an era, not the arrival of one. Late
modern spin is not about the preservation of an ideal artifice, but the
management of complex emotional narratives. This is the difference
between today's spin and more traditional manipulations of image,
for which containment was irrelevant or antithetical, and compression
a disaster. Image management today must *embrace* compression, and
try to use it to advantage.

Bill Clinton marked the arrival of this new era. It was often said
during the Lewinsky affair, when his relationship with a White House
intern became public, that Clinton was a very "compartmentalised"
president and person, referring to his ability to continue conducting
the business of state in a focused way while often having to break off
to attend to those aspects of his private life which became public, not
to mention attending to the consequences of all this within his family.
However, a more telling spatial metaphor would be that Clinton was
a "compressed" president, indeed was the world's first fully com-
pressed national leader. His image became an inseparable fusion of
the political and the sensual; he was seen both as a politician still
widely respected for his policies, especially domestic ones, and also as
a person of intense libidinal need. The libidinisation of the presidency
might have begun with Kennedy and his glamorous image, but in that
time most of it was a secret. A great deal more sexual activity might
have occurred in and around the White House then, but it was not in
the public domain. In the compressed public culture of the millennial
era, however, it is possible for the electorate to be as fully acquainted
with the president's need for sexual intimacy as they are with his

welfare policies, *and* for his authority to be undimmed by this collision of spheres.

It could be argued that the electorate's continuing support for Clinton, and the consequent failure of the impeachment, expressed a popular decision that the private life of the individual is irrelevant to the discharge of public duties. Such a decision to bracket off the public from the private would not fit with the model of compression proposed here, because it would consign the personal sphere of sexuality back to the private domain, and demand that we cease to be interested in what our leaders get up to in private. This is not feasible; in this therapeutic age we are all too interested in what people feel and do in all areas of their lives. Rather, the continuing popular support for Clinton can be read as forgiveness, an acceptance of the carnality of the president rather than an attempt to ignore it. It was a rejection of the prurience of the official inquiry into his misdemeanours. Sex is now forgiven; even using the office of state to secure indiscreet extramarital sex is forgiven. If there had been evidence that poor judgement in the conduct of extramarital affairs was linked to poor judgement in the conduct of affairs of state, the outcome might have been different. Some might want to argue that such a link must exist, but that argument appears to have been rejected by the majority. They were interested in the president as a flawed person, but did not think he was necessarily, thereby, a bad president. The president was allowed to continue as president, with a public image into which a profuse imagery of his disorderly carnal being had been compressed.[2]

To summarise, some predictions can be offered. We have been considering two factors: the increasing importance of containment as a dimension of credible authority, and the increasing compression of public figures. These are distinct factors, but they are both part of the burgeoning of therapeutic culture, in which there is an increasingly explicit concern with the emotional self, its internal conflicts and their regulation, and in which a more diverse range of social institutions, including political leaders, have come to play a role in supporting emotional management. We can describe this in terms of a shift from a classical modern to a late modern mode of emotional management.

In the political sphere, this shift means there will be more attention paid to the containing qualities of political communications, and that there will be more compression of public figures. The images, the public personae, of politicians will be infused with elements of the

emotional and sensual being of the leaders as persons, and in the public domain a web of analysis, fantasy, judgement, and speculation will surround these elements. Authority figures will be placed, like everybody else, in complex psychosocial narratives in which strength and weakness, virtue and failing are closely and explicitly interwoven, and the everyday qualities of political discourse will come to reflect this. The same will be true of other aspects of the public domain; large commercial organisations, especially those involved in basic consumer provisioning, such as retailing and financial services, will seek to acquire more compressed and containing corporate images, as consumer markets register more fully the changes in the nature of authority.

At the same time as public interest in the personal life of public figures will increase, so will tolerance of weakness in personal life. The threshold for demanding resignation over a range of issues concerning personal life will continue to rise, except in relation to any security risk element to the story. Where individuals do resign, the speed and fullness of their return to public life is increasing. We can expect that a compression of Clinton-esque proportions might, at some point, occur in the UK.

Another phenomenon that the analysis presented would lead us to expect is the coming of a *damaged* leader, someone who, as a person, has been wounded and healed. Such leaders illustrate the principles of both compression and containment. People of this sort, in whom suffering is compressed with cure, can inspire a certain kind of confidence most powerfully. Their history of damage and repair can give hope that the leader can understand and contain the anxieties of others. The person who has been to the brink, or gone over the edge into illness or trauma, yet survived to lead a richer and wiser life, is potentially a model of resourcefulness and tenacity, and of how containing powers can develop.

The conventional fear that in the age of spin all politicians will be under increasing pressure to resemble a normative, antiseptic image of health and probity is, therefore, misplaced. Without underestimating the forces still around us pressing for the defensive construction of leaders as persons of pristine normativity, it is more likely that leaders of scarred identity and visibly flawed character will emerge, though crucially as persons they will be functioning as restored wholes.

Notes

1. Alas, the relative optimism of the 1990s had, at the time of writing this piece, clouded the author's judgement. At the present time of writing, we await the inauguration of an American President who looks certain to break the therapeutic trajectory of the Bill Clinton to Obama years. Less certain is what style of emotional regulation he will offer; while it will not be a return to the Reagan Hollywood model, how Donald Trump's disinhibited aggressivity might shape his administration's emotional governance in the coming years is unclear.

2. We have seen something similar in Trump's campaign for the presidency, when evidence emerged that here was a sexually predatory individual. Those who voted for him presumably either had no real problem with that, or saw it as less important than other features of his person with which it was compressed in his public image. Instead, some of the potential public anger at lack of integrity in a presidential candidate appears to have been displaced on to Trump's rival, Hillary Clinton. The chants of "Lock her up!" heard at Trump rallies brought a new vigilantist strain into campaigning. Their origin could have been in a response to her as the cheated-on wife whose simple presence demands guilt and contrition from a sexually acquisitive male, and who is, therefore, angrily turned on in the expression of a more general misogyny, or perhaps in just another spurt of bilious rhetoric against the Washington elite.

A new psychosocial theory of nationalism

Containment at the level of social organisations

To draw the analyses presented in previous chapters together, and to extend the core idea of this book into the domain of politics, we will return to the concept of containment. Those familiar with this term in the works of Bion and other psychoanalysts will know that it refers primarily to a relationship between two minds, in which one—the container—receives the projected anxieties and terrors of the other, and withstands and processes them, thus enabling the other to both take them back in (to "reintroject" them) in modified, tolerable form, and also to take in an experience of a mind capable of processing extreme levels of anxiety. Thus, the carer plays a profound role in the mental development of the baby, offering a model of how to live with anxiety, and the therapist can provide therapeutic experience for the patient. Whether or not you accept the specific propositions of Kleinian theory that the baby is subject to psychotic anxieties, and feels it is dying, this model of transformative soothing offers a poignant vision of psychic growth.

In this developmental and clinical sense, containment is, by definition, a function of an interpersonal relationship, and some might wish

to restrict the term to that context. However, in his classic *Dictionary of Kleinian Thought*, Hinshelwood (1989, p. 246) has observed that "society itself may function as an emotional container of one kind or another". Indeed, Hinshelwood regards Bion's theory of containing as a theory of society. However, he completed the sentence just quoted from with the phrase "more or less defensive". So the kind of emotional container that societal structures can provide is seen as *defensive*, not the mind-enhancing kind which people familiar with the psychoanalytic concept might first think of. Defensive containers still depend on a process of projective identification and reintrojection, but the container does not provide the processing of anxiety that detoxifies it for the other. The modelling is of defending against, not processing and tolerating, anxiety.

Hinshelwood points to the early, well-known work of Jaques (1955) and Menzies Lyth (1959) on how social organisations can function as psychic defence systems for the individuals who work in them. People might behave in ways that suggest they are anxious and unhappy in their work and which are not good for the organisation they work in: for example, they might become increasingly liable to take sick leave or to quit their jobs. Organisational consultants thinking psychoanalytically and systemically about the situation might conclude that the problem is due, at least in part, to arrangements that the organisation has put in place to try to deal with problems affecting staff. Menzies Lyth's classic example was of high turnover among nurses. Hospital managements believed that nurses were stressed by working with patients in serious conditions that caused them much suffering, and, accordingly, organised their work so that they were not in consistent contact with the same patients, and were unable to form personal relationships with them. The theory was that less emotional involvement would reduce the emotional stress, and contain the nurses' anxieties. In fact, less opportunity to relate interpersonally with patients made their work less meaningful and satisfying, and contributed to the high turnover.

Let us look briefly at an example from higher education. The huge expansion of the higher education sector from the 1960s onwards has generated concerns about "dumbing-down" and "grade inflation". These concerns are about whether the academic standards expected of students in the previous era, when higher education was an elite privilege, can be maintained in the present era, when students are a

much more diverse population, and many more people are needed to teach them. The official answer from the university sector is, unsurprisingly, yes: those standards can be, and are, being maintained. For evidence of this, we are pointed to a huge machinery of "quality assurance and enhancement" (QAE), an assemblage of benchmarks, criteria, templates, reports, committees, procedures, and personnel all designed to reassure government and the public that university degrees reflect the same standards as in times past. This machinery—almost unknown half a century ago—has grown in step with the growth of the sector.

Ideally, academic staff would be reassured by this machinery and, no doubt, some are. Some others, however, feel strongly that standards are, none the less, in decline. In reality, this is a complex area that does not admit of a single "yes they are"/"no they aren't" answer. It depends on what is meant by standards, and on what we value most in a university education. For those who believe, rightly or wrongly, that grade inflation is a problem, the apparatus of QAE is seen to be failing, and simply applying more of it will not solve the problem. For example, requiring a university to ensure that its standards are comparable to those elsewhere in the sector will not achieve anything if the problem of falling standards is one afflicting the whole sector. Among those anxious about this, there are different diagnoses of exactly what the problem is, and why QAE is failing to fix it, but there is a shared sense of demoralisation, of complicity in something wrong, and of anger or despair at what is seen as the failure of individual university management teams and relevant national bodies to understand the problem.

While that group could become more fractious and alienated from their universities, others might pursue quality control measures in a more exaggerated manner, in the belief that this is the only way to manage the threat of decline. Others will have more complex or ambivalent views, or be more indifferent. But whatever one's views on the question of academic standards, there is a case to be made for seeing the apparatus of QAE as an attempt by HE organisations to manage anxieties which—in consuming resources, placing more demands on academics, and failing to convince of its efficacy—is actually adding to the anxieties of some people within those organisations, and to levels of intra-organisational tension. The apparatus is, at least in part, failing as a container. Some parts of it might be working as intended, and, undoubtedly, there needs to be a "quality" apparatus of some sort to support the management and regulation of a large and

complex part of our social infrastructure. However, the actually existing set of institutional and sector-wide arrangements is being experienced by some as a false or pseudo-containment, a set of arrangements that fail to address a problem, either because its existence is denied or because they pursue a false solution to it.

Analyses of organisations as containers have been a very important development in psychosocial theory, and have helped to establish the credibility of using psychoanalytic concepts in the study of political processes. However, what follows on the subject of containment and the nation-state differs from this sort of analysis of social containers in two major ways. First, my proposal is concerned with potentially positive forms of containment. The idea of the good container is not absent in the work of psychoanalytic organisational theorists, because, if some procedures are defensive, there could in principle be others which are containing in a positive, therapeutic sense. However, the overall rhetorical influence of this work, in an echo of Freud's deep suspicion of all social groups, has probably been to support the idea of the social organisation as a naturally defensive force which individuals have to grapple with, or disengage from, if they are to face practical and emotional realities.

Second, we will move outwards or upwards from particular organisations to the level of a whole society, by which I mean the nation-state. In this globalised age, we must obviously qualify the idea of a "whole" society, since no nation-state is a self-sufficient island. Our everyday experience, most directly through our consumption of media and material goods, is increasingly influenced by people and events outside of our national society. Yet, nation-states are still jurisdictional territories, with their own distinctive structures of governance and their national media. They are often, though not necessarily, marked off from neighbours by language. While a disturbing number of current examples are barely functioning or have collapsed, the nation-state is the dominant form of polity around the world, and its boundaries are often taken to define a "society". It is currently the constitutive unit of global civilisation.

The nation as core identity

In the rest of this chapter, we will examine the psychology of the nation-state with reference to the concept of *societal* containment. By

this, we mean the containing function fulfilled in our emotional lives by the structures, processes, symbols, and so forth of the society in which we live. As the conservative philosopher Roger Scruton has put it, there is a "feeling of primal safety that the bond of society brings" (Scruton, 1999, p. 291). Conservative social philosophy has been particularly attuned to this dimension of subjective experience, although has produced few explanations for it. At this very broad and basic level of societal membership, we will examine two major sources of containment. One is the nation as a cultural community; the other is the state itself, the boundaries of which define the society geographically.

To understand the psychological significance of the nation, I am drawing heavily on the work of Volkan (2004, 2013) and his concept of large-group identities. He has extended the Eriksonian project (the work of the American psychosocial theorist, e.g., Erikson, 1959) of developing a psychoanalytic concept of "identity". He uses the phrase "core identities", to refer to those identities which have deep psychic roots. We have core personal identity, and also a core large-group identity, which will be based on whatever large human collective(s) or category(ies) we choose to feel part of and to install as a core component of our identity. Foremost among these categories are ethnicity, religion, and nation. Volkan's work is the most intensive and empirically based application of psychoanalytic thinking to international politics, in which crucial insights into many enduring conflicts can be found. He argues that we need collective identities as much as we need personal ones. Disruption of or threat to core large-group identity will, says Volkan, produce strong emotional reactions.

This is because of the importance of that identity in our psychic lives. The sense of belonging and meaningfulness which large-group identity can impart has frequently been documented by social psychologists. It is also clearly registered in the psychosocial work of Elias in his historically rich discussion of the "we-feeling" of nationalism (Elias, 1996, Section II). He notes that "the image of this [national] 'we' forms an integral part of the personality organisation of the individual" (1996, p.153). At the most fundamental level, a strong collective identity can be seen psychoanalytically as a shield against, or antidote for, psychotic fears of fragmentation. In other words, it has a strong containing function. Containment, in this sense, is a process taking place in the mind of one individual, though it

requires an external object (whether material or symbolic) into which qualities of coherence, meaning, and reassurance can be projected, and which can then be available for reintrojection as an experience of wholeness and safety. The idea of one's nation, and images of its vitality and durability, can offer such an object. This kind of large-group identity offers a place to be, and a cloak to throw around yourself to hold yourself together, which will also signal to other people that you exist and have a place in the order of things. In Anderson's oft-repeated phrase, the "imagined community" of the nation (Anderson, 1983) can be an important psychic resource for individuals, albeit one often operating as a kind of background container, perhaps as a containing "skin".

The nation as core cultural identity

Volkan himself does not make much use of the idea of containment, but we can see large-group identity as having a containing function in the manner just described. The nation is a frequent source of such identity, and so it would follow that the nation is, in some way, an important container of anxiety. In the terms "motherland" and "fatherland", we can see efforts to create the nation in language as a good containing object, nourishing and protecting, and as a source of affirmative meaning in life. All too often, however, these efforts tip over into idealisation of the nation, accompanied by denigration of an "other". Typically, in aggressive forms of nationalism, there will be very little substantive elaboration of a specific national identity; what are often called "ethnic" nationalisms often reduce to assertions about genetic inheritance, or rest on an inchoate imagery of body and matter (blood, heart, soil, land, etc.). We might still think of these as "cultural" identities since, in the sense of culture as a way of life, they are intended to define the nation as a culturally homogenous community.

It should be noted, however, that it is not only angry ethno-nationalists whose experience of the nation is coloured, consciously or unconsciously, by an image of it as a body. As noted in Chapter One, the rural areas of a nation are commonly experienced in somatic terms. Even the politically neutral languages of topography and cartography lean heavily on a vocabulary of the body, in the use of

terms such as head, mouth, brow, neck, shoulder, foot, and back. In particular, the idea of the land we walk on, the soil, as a life-giving and life-supporting presence is both a banal fact of ecology and (because of that) a powerful unconscious phantasy of the land as a maternal object, fecund and embracing, whether in the containing, domesticated form of the agrarian countryside or in the excitement of the wilderness. In defending against anxieties about the loss of this maternal object, we might fill it with narcissistic projections and mythologise it as a blessed motherland (or proud fatherland). Since territory is a fundamental defining feature of a nation-state, the geographically defined but idealised "land" or "country" can then become a key element in people's experience of the nation they inhabit.

However, an idealised mythology is not the only possible elaboration of the phantasy of the "body" of the nation. An aesthetic appreciation of the land, linked to gratitude towards "nature" and to those who have worked on "her" in culturally specific ways to produce food and other essentials, need not be linked with defensive glorification of a simplistic picture of that culture.

But here we are back to the negative picture of large-group identities, which, in the default tradition of psychoanalytic thinking about them, are seen primarily as sources of human conflict and misery. For Volkan, they are based on fantasies about the past and/or the future. His concepts of "chosen glory" and "chosen trauma", historical events or myths that provide the symbols of triumph or tragedy around which large group identities are built, capture well the key features of many such identities, and help to explain the often destructive passion with which they are clung to. They are containers, of a sort, though not usually good ones. They typically help to defend against anxiety by denial, splitting, and projection, rather than helping to manage it by acknowledgement and working through.

In this way, the large group, and perhaps especially the nation, does not emerge well from the psychoanalytic work on collective identities. This is not surprising, since psychoanalytic writers on this subject are likely to be people who hold nationalism in some suspicion. National sentiment is something which many educated cosmopolitans tend to view from afar and with distaste. We allow ourselves to get a bit closer to it when our national team is competing in sport. In that context, we might enjoy the taste, at least until some section of the crowd or of the media starts performing the ugliness of

nationalism. And there is no way to exaggerate the ugliness of nationalism when it gets going. Writing in the shadow of its capacity to mobilise destructiveness, some observers of nationalism have concluded that it is, in itself, essentially a bad thing. If that is so, then the object of nationalist feeling, the nation, is something we must view with deep suspicion. We might have to put up with living within it, but we do not want it to become a vehicle for any collective emotion, as that would open the door to regressive bellicosity towards other nations, and aggressive "othering" within one's own.

In that view, the only acceptable form of nationalism is the sanitised "civic" variety, in which national identity is a kind of automatic psychological correlate of citizenship. A nation comprises all those who live in it and abide by its laws and pay its taxes. No commitment to any substantive values or sense of cultural connection to other citizens is required. For civic nationalism, national identity is not affectively charged, not culturally defined, nor functional as a core identity.

However, we do not always see *affective* nationalism as necessarily bad. We know that some nationalist liberation movements have been major factors in the break-up of oppressive empires, and some separatist nationalisms have stood up against repressive regimes. In the current British context, we can see Scottish and Welsh nationalisms as expressions of a desire for democratic self-determination and progressive politics which some might think is wrong-headed, but which merits serious debate. So, although we might be wary of some separatist movements with racist undertones, we can be comfortable with nationalism when it is the vehicle of what we see as a progressive or liberation movement.

Moreover, some theorists of nationalism,[1] and many ordinary people, do see the possibility of a benign form of cultural and affect-laden national identity which is not dependent on regressive malignant "othering". At the popular level, this more positive image may be based on an idea that a few broad and strongly positive qualities are highly characteristic of a national people, qualities such as tolerance, compassion, generosity, hospitality, or humour. Or some "neutral" practices, such as playing a particular sport, consuming particular food or drink, forms of dress, etc., can be taken as emblematic of the national community, as markers of shared experience. Such images might be elaborated and grounded in a narrative of the nation's history. Although usually inhabited in a more background way and

with less intensity than regressive forms of nationalism, this kind of cultural identity can still occupy a core place in structures of identity, and serve as an integrative and containing element in the psyche. It can posit the nation as a flawed but good object, different but not superior to other nations, and, thereby, support a reality-based and constructive engagement with civic life and democratic politics.

Polling data supports the claim that such benign nationalism is the predominant form in Britain today, even if not by a huge margin over more ambivalent or regressive forms. For example, major surveys by YouGov (Kellner, 2012) and IpsosMORI (Atkinson et al., 2012) found a majority to define Britishness in terms of values held (democracy, tolerance, and contribution to society), rather than in terms of ethnicity.

The nation-state as ultimate authority

We shall return shortly to the deep ambivalence within and towards the nation as cultural identity; for now, let the nation as cultural community be noted as at least a potential source of societal containment. The second such source is not to be found in an idea of the nation, in the history and culture of the nation as an imagined collective to which we belong and from which we draw an identity, but in the existence of the nation-*state*. There are two sides to the state as container; these aspects of the national experience have been less explored in the literature on nationalism, and their implications not considered by psychoanalytically orientated writers on the subject.

The state is the ultimate authority in our lives, though in many countries it might be challenged on occasion by a transnational body, such as the European Court of Human Rights. As the holder of a monopoly on legitimate violence, it is the final guarantor of security for its citizens. It protects us against each other, and against external threats. The modern nation-state stands as authority in both symbolic and material ways. In the symbolic realm, it is typically draped in the powerful abstract ideals of democracy and justice, and it is represented by the imagery of legislative and judicial power. Materially, it is embodied in inexorable constitutional and legal processes and their enforcement by the police, as well as by its military arm.

Despite the frightening and alienating effects all this can have on some citizens, of which more shortly, my contention at this point is that

this authoritative role of the state occupies a *quasi*-parental space in the psyche. It embodies the protective and also restraining function that developmentally was exercised by carers. As such, it provides objects of experience which can sustain the sort of containment process which has been the central concern of this book. Speculatively, while we might see a large group identity as helpful in containing fears of fragmentation, the state experienced as protective authority could be particularly relevant to the containment of paranoid anxieties about attack, and of depressive anxieties about our own destructiveness.

The nation-state as ultimate provider

The state is also the ultimate provider of the material goods necessary for life, through the material reality of its day-to-day functioning. This is a source of containment, though one different from containment by a grand narrative of nation, or by the symbolism or exercise of protective power. Where citizens might lack the basic necessities of life—food, shelter, and so on—the state is the provider of last resort, at least in those nations with welfare systems. This safety net might, in practice, be a bleak and loveless provision, in contrast to the loving nurture of good parental care, but it can still serve as a sign that there is societal rescue from life-threatening destitution, and so its existence could serve to mitigate primitive fears of abandonment.

More positively, the state is also, in one way or another, the provider of the mundane, life-supporting functions of public utilities, a dimension of experience which is not so much background as completely taken for granted, and which is sometimes literally underground. In Chapter Two, this role of the state was discussed via two examples, both of which focused on aspects of urban public space, an environment which, in the UK, is largely provided and maintained (albeit increasingly through intermediaries) by governmental authorities that are part of the overall national state apparatus. Here, the containment is not only of primitive fear, but also of more sophisticated anxieties around personal identity and how we manage that in public. We expect that although we are out in public, we can go about our private business, whatever that might be, and not be called upon to attend to anything specific or to take part in anything unless we want

to. Public space is neutral, orderly, and fairly predictable. This is obviously a cultural achievement, but it does depend on a material, administrative, and legal infrastructure (paving, public transport, bye-laws, policing, etc.). By such means, local and national government create spaces for economic, civic, and cultural life, in which individual safety, privacy, and freedom of movement can, at least in principle, be expected. Managed public space is, therefore, a container wherein we can enjoy the benefits of community without fearing attack or loss of autonomy. We can examine this process more closely by developing one of the examples used in Chapter Two, which concerns our relationship with street lighting.

Looking at a streetlight against the night sky, we can experience both the fear of the dark and the reassurance of the light. We know the darkness is there, and are aware of its deathly power to engulf us. Yet, the light testifies to the possibility of creating a safe space within which life can continue. Of course, the streetlight itself does not carry that meaning; it is simply a device for transforming electricity into light. However, the light that it shines does serve to mitigate those fears of abandonment, persecution, and death which darkness generates. Our fears can, thus, be moderated and contained, even though the streetlight has been a passive, non-human object. We have projected into it the capacity to protect and reassure, which we can then (re)introject as confirmation of our capacity to withstand darkness and the threat of obliteration. We can have done so only in so far as the device in question has actually provided light; if it failed to do that, the containing loop of projection and introjection would be broken, but as long as they work, there is a possibility for us to receive from streetlights an experience of being held in safety.

Held and contained, though, by whom or what exactly? The suggestion that our impersonal socio-material environment can have a containing function implies that we can locate the containing agency in the fabric of government. When out enjoying the benefits of well-lit streets, we do not stop to think who decided to put those lights there, or who actually installed them. However, on the assumption that few things escape the attention of our vigilant unconscious, we will, somewhere in our minds, be registering the social other as responsible for this beneficial installation. More specifically, it is a *societal* other whom we must thank: it is not usually our family, friends, or neighbours who put them up. And the same goes for most for the

material infrastructure of society—the water that flows into our homes, the sewage that flows out, electricity and gas, telecommunications, transport networks, pavements and roads, parks and other public spaces, etc. As we use any of these resources provided by the societal other, there are similar loops of containment available to us.

Although we might have many criticisms of how specific parts of this infrastructure are developed or managed, and despite whatever levels of private finance might now be involved in creating the public shared goods of our infrastructure, the government is still the ultimate creator of this material fabric, through its initiating, planning, and funding roles. The state stands within the societal other, at the centre of its activity as the unspoken provider of public utilities and spaces.

In consuming all these social goods, the individual can find in the external world objects into which experiences of relief and satisfaction can be projected, so that they are experienced as containing sources of reassurance and goodness. As I have suggested, these qualities can then be introjected and re-projected to set up a benign cycle of exchange between internal and external worlds. Although the individual is the only psychic agent involved, there is an exchange between inside and outside. The objects into which the individual projects must have some objective characteristics that make them suitable for their roles as containers.

So, the actual powers that are held by the state offer a particular type of societal containment, in which the artefacts and processes of actually functioning society present an array of potential targets for projection of both anxieties and of capacities to contain. Given the reality of how those external objects function to produce tangible benefits, and the fact of their origins in collective human endeavour, they can be reintrojected as enhanced containing objects bearing the imprint of the societal (national) other. As such, they would strengthen the individual's capacity for self-containment. They function in the mind of the citizen to help process anxiety by affirming the capacity of human society to care for its members.

So, our inevitable immersion in relationships with the material embodiments of the societal other will deposit in our minds some rudimentary images of national government as a potentially containing object. "Government" here refers to the enduring state, not the

particular political administration of the moment, though at times the two may be equated in the mind of an individual.

Clearly, this analysis can apply only in societies where the material infrastructure is largely intact and functioning. An implication of the analysis is that where it has been destroyed, or has never been properly established, an important dimension of societal containment will be lacking. There could be consequences of this for the emotional wellbeing of the population, since an important source of emotional capital will be absent. It would also make it likely that the state would have more difficulty in establishing itself as a realistic good object in the minds of its citizens.

As well as providing the reassuring infrastructure of society, the contemporary nation-state has also been essential, through its resourcing and regulatory roles, to the creation and dissemination of many cultural goods. In the UK, the BBC, while it has slipped in public estimation in recent years, can still be seen alongside the NHS as an iconic "good object" legacy of the twentieth-century interventionist and creative British state. In the cultural sector, the generative and curatorial roles of the state have more recently been obscured and eroded by market forces, but it remains the ultimate guarantor of national "high' culture. Much popular culture, as will shortly be emphasised, is far less linked to a national identity.

The nation-state as containing object

Overall, my hypothesis is that the *quasi*-parental functions of protective authority and nurturing provision endow the state with powerful unconscious resonance, however distant or alienated from it any individual might feel. In its functions of protector and provider, the state is the actual source of many potentially containing objects in our everyday environment. It is where we turn for defence, both against those who wish to do us harm, be they antagonistic neighbours, domestic criminals or self-defined enemies on the other side of the world, and against the forces of nature, be they storms, floods, disease, or infestation. It is also the producer or the guarantor of the material infrastructure of society, and, for most of us, it is the primary or sole provider of the life-giving social goods of education and the health and welfare services.

We might expect, therefore, that, in internal reality, the state would be the ultimate symbol of human interdependence, and of protective and nurturing authority. It is a dense nexus of, and control centre for, a countless number of the material and legal/contractual interdependencies between people that, according to Elias (1996, p. 146), are the fundamental constitutive matter of human civilisation. He calls these the "factual bonds" or "factual interdependencies" of "millions of individuals belonging to the same society, . . . interlinking through the occupational division of labour, through integration within the same framework of governmental and administrative organisations". Although our ultimate dependencies are often on unknown people in unknown places, and reach far back into the past, the state—which means the nation-state—is the ultimate link between them and us, and also is very often the proximate or tangible provider.

In its embodiment of the powers of both authority and nurture, the nation-state has great potential for being, in the minds of its citizens, an overarching object able to reassure, to convey to individuals the power of human society, and of the minds within it, to mitigate anxieties and to find meaning. In other words, it has potential to offer some sort of containment.

This material, practical aspect of the state's containing power also has an aesthetic dimension that links it to the cultural component of national identity. The actual delivery of many of the protective and provisioning aspects of the state often involves particular designs, styles, liveries, symbols, etc. Goods, services, and facilities come in particular aesthetic packages, determined by factors such as local architectural vernaculars, typographical choices, linguistic conventions, and so on. Such features easily become clichés—the British red pillar-box or telephone box—yet the shape and colour of post boxes, the design of signage, or drain covers, or electricity sockets are recurrent features of the visual environment which are intrinsic to our experiences of public utilities. In combination, they create the possibility for residents to experience a national–homely feeling in many public and domestic spaces. Of course, they can also be objects of irritation or frustration, but homes are places where people can feel angry as well as safe. They can also generate a sense of kinship among those who have in common the experience of depending on their particular features and functionalities.

The nation-state as failing container

In the nation-state, therefore, some major sources of societal contain-ment are brought together. In our relationship to the nation-state, our feelings about our nation (as imagined collective) are linked with our feelings about the state as protector and provider. So, it should follow from what has been said so far that the nation-state has, in theory, the potential to offer substantial resources of containment to its citizens. However, these theoretical propositions must now come up against reality, against the obvious observation that, in fact, the nation-state is *not* widely experienced as a good object, even in the UK where infra-structural containment is relatively strong and where we have the good object of the NHS, though perhaps this, some time ago, became an idealised object, representing a principle rather than a reality, float-ing above the actual health service with its real strengths and weak-nesses. Moreover, that idealised object carries an aura of intense anxiety, a sense that it is under threat, whether that is from govern-ment, from its own management, from the demands placed upon it, or from elsewhere. While some of that anxiety must belong intrinsi-cally to the area of health care, where the threat of illness and death is ever-present, some might belong to the NHS as symbolic of a national community that is felt to be dissolving, or which has been lost.

Whatever the realities of the British public's experience of the NHS, for some people the phrase "the containing nation-state" would be oxymoronic, unless it referred to a perverted form of containment. The nation-state is widely seen as a bad object, often a very bad object. For example, a basic duty of the state is to ensure the safety and secu-rity of its people, yet the term "security" is, when taken in relation to the state, now often taken to connote domination, discrimination, and violence.

So, although, as also noted earlier, we might view some forms of insurgent nationalism with sympathy, once a nation-*state* actually exists, the mobilisation of affect around it—unless, perhaps, it is being threatened by a greater power—is likely to be a cause for our disquiet, let alone the idea that it might have an important part to play in our psychological wellbeing.

Overall, then, it is plausible to claim that, in recent decades, the institutions of the liberal nation-state have become objects of wide-spread hostility and resentment. At the very least, they seem largely

to have lost whatever reserves of trust might once have been placed in them. As the sociologist Dennis Smith puts it, we have witnessed a "decreasing capacity of the nation-state to contain and structure our lives" (Smith, 2006, p. 15). This can be understood geo-politically, as a consequence of various developments that gained in strength in the final decades of the twentieth century. These include the actual weakening of the nation-state as globalisation proceeds and capital increasingly exerts its powers transnationally, and the rise of neo-liberalism, with its demand that the state stand aside and let markets structure our lives. There are very extensive debates about these factors, which we cannot go into here. Whatever their respective contributions, the point of relevance for the present argument is that when citizens do not cathect the nation-state as a trusted and efficacious object, its power to provide effective emotional containment for its subjects will diminish.

Let us consider the psychological concomitants of this decline of the nation-state. We should call them concomitants, as it is unclear whether they are the psychological *consequences* of a weakening process that is driven geo-politically, or whether they are additional *causes* of that process. They are probably both, to varying degrees.

The decathexis of the nation is partly driven by the wish to avoid the aggressive side of nationalism, which we could see either as a consequence of an ever-more interconnected world, or as a facet of greater emotional maturity among sections of the general public—or both. The effects of national identity, when it commands the psychic space of core large-group identity, often seem to be to generate conflict and channel hatred. At the least, nationalism is too often associated with insular and exclusionary outlooks and practices. Consequently, among some sections of the public, the nation-state is now a damaged object because of its closeness to nationalism. There is greater readiness to identify jingoistic and xenophobic tendencies, and to decry them. Anti-war movements attract substantial support. Anti-nation states of mind are now commonplace.

There is also a wide influence today, across the political spectrum, of anti-state sentiment. Ideologically, this complex pool of political affect derives from disparate sources, including left-wing libertarianism as well as right-wing neo-liberalism. Some people might well have concrete reasons for animosity towards the state: they might feel they

have suffered at the hands of its representatives, whether they are in the courts, the police, the benefits office, the social work department, or elsewhere. Others might acknowledge the debt they owe to the state for their education, health, and employment, yet feel deep anger towards it for its pursuit of policies with which they disagree. Whatever their psycho-societal and political roots, today's very diverse and widespread antipathies towards the state all feed into the gathering failure of the nation-state as an emotional container.

On top of these deep-seated developments, there has been a growing failure of national political leaderships to command trust or inspire engagement among their postmodern electorates. Our political classes seem to have limited competence in the tasks of emotional governance, a weakness examined at some length in my book *Emotional Governance* (Richards, 2007). Partly as a consequence of this, we have a largely hollowed out public sphere, drained of emotional reality and spontaneity, and dominated by an inauthentic and dysfunctional party system.

Party politics as a failing container

In many Western democracies, the party system is another major source of the declining ability of the national polity to provide its citizens with a sense of security and meaning. To say this is not to endorse the prevalent cynicism that easily sees all politicians as hypocrites or crooks. Neither is it to put all the blame on the media for their role in creating and sustaining that cynicism. While the media-led assault on politics is arguably a major factor in the decline of democratic involvement, the media coverage of politics feeds off what has become the inherent implausibility of a tribal party system and the emotional inauthenticity it demands. In a therapeutic culture, authenticity is a paramount value. In the UK, the Manichean logic of a system dominated for decades by two parties had a rationale as a reflection of the material and ideological interests of the stable socio-cultural blocs of capital (and its functionaries) and labour (and its fellow travellers), loosely speaking. Our visions of society were organised in a basically binaristic competition. This endowed the tedious ding-dong exchanges of parliamentary life with some higher purpose, and with some fidelity to the passions of the electorate. Enough of us identified

with the political tribes, and so were ready to accept the self-right-eousness of the party protagonists, for the system to feel meaningful and right.

However, this obscured the emotionally impoverished nature of a system in which "we" are always right and "they" are wrong. With the dissolution of the class blocs that previously underpinned its ideological rationale, the party system has degenerated into frequently empty opposition, and "de-alignment" has arrived. This term normally refers to the de-alignment of voters from automatic allegiance to traditional ideological packages and the parties that went with them, but it could also refer to the decoupling of voters from the whole democratic process. Now we have substantial values convergence between the major parties, the policy differences between them—while still sharp at times—do not consistently reflect differences of view between the same large groups of the electorate. For individual voters, increasingly unable to identify with an overall ideological package, an exclusive emotional investment in one party only—which is what "one person one vote" requires—makes little sense. With no social traditions or material interests to dictate party allegiance, more people come to experience the banal binarisms and narcissism of the inter-party competition as a charade, or as a self-interested game organised for the benefit of those who actively play it—politicians and their following.

A new gulf opens between the political classes and the rest of us. The consequent crisis of trust, orchestrated by the media, does not stem essentially from the actions of politicians (who are no less trustworthy than in the past), but from the growing inability of a two- or three-party system to offer effective political theatre. However sincere their commitment, politicians are trapped in a theatre of inauthenticity. Some of us might continue to feel that the major parties do represent, albeit faintly, a consistent choice between basic values but those who believe absolutely in a party cause are now on the margins of the emotional public sphere. While they might continue to be articulate and cogent representatives of different positions on specific issues, their generalised partisan fervour and point-scoring is increasingly felt to be aberrant and suspect, out of touch with the sensibilities of the time. Party politics does not feel right. New forms of democratic drama are needed to bring more authentic styles of political leadership to the fore.

In the UK, in recent years, there have been fears that declining electoral turnout will drop below the critical level required for elections to have legitimacy. Most commentators on this problem have discussed it mainly at the level of the party system, and seen it as a problem of "connection". Voters are failing to engage and connect with party politics; party politicians are failing to reach and connect with the electorate. These are both accurate observations, and we can choose between various apportionments of blame between those two sides of the problem. However, the problem goes much deeper. There is no adequate party object for us to connect with, due in part to the fundamental inauthenticity of the tribalised party competition. Beyond that, as the wider analysis offered in this chapter would suggest, it rests yet more deeply on the diminishing capacity of the political sphere in the nation-state to offer emotional containment to its citizens.

Consequences of failed containment

In cynicism and disengagement from the democratic process, we see a slow, passive attack on the disappointing container. Alongside that, there is another symptom of the nation-state's weakened emotional valence. This is a more dramatic and acutely disturbing one: the rise of political extremism, especially of kinds willing or needing to visit violence on their fellow citizens. Explosive attacks on the national container planned, and in some cases launched, by violent Islamists cannot, of course, be seen as entirely the result of conditions within the nation, since they are occurring around the world and have global origins and aims.

However, the plots and attacks of domestic terrorism embody a hitherto unthinkable level of murderous hatred of the conspirators' fellow nationals, which might not have been so ready to emerge had the nation-state been a stronger and more containing vessel, able to absorb and detoxify the fears and impulses of its now more variegated population. In its condition now as a weakened or, more often, a bad object, the nation-state is easily represented to the prospective terrorist in the terms of extreme Islamism. These declare it to be an evil challenge to the will of Allah as expressed in the rule of the Caliph, and its citizens, therefore, as deserving of bombs, bullets, and knives. The domestic terrorist must either have no identification with the nation, no affective

link with it, or be attacking that part of him/herself that is identified with it. In either case, the installation of the nation in the collective psyche as a more robust good object, flawed but deserving of some gratitude, would be a deep emotional resource for counter-terrorism.

On the face of it, the rise of violent extremism on the (apparently) opposite, ethno-nationalist front seems to be a result of a very different intrapsychic positioning of the nation to that in the Islamist case. For the extremist on the "Far Right",[2] the nation as an internal object appears to be swollen with projected narcissism. It is often assumed that the more aggressive forms of nationalism, those associated with racism and active hostility towards people defined as outside the nation, are simple exaggerations of a nationalist sentiment which comes in varying intensities but is always fundamentally of the same quality. In this view, any love of country differs only in degree from xenophobia, and worse.

This understanding can be challenged, on two grounds. First, in ideological terms, aggressive ethno-nationalisms do not typically address the nation in a real sense. In the UK, a substantial number of would-be neo-Nazi terrorists have been arrested and convicted in recent years, but neo-Nazis generally do not have much to say about national identity in any substantive or "lived" way. Anders Breivik, for example, was not interested in defending Norwegian identity, but "Christian civilisation". The British National Party, a modernised remnant of British fascism that, for some time, was the leading organisation on the British "Far Right", developed some narrative of British patriotism, but this was part of an effort to mainstream itself and become an electoral force, an effort which failed quite early. The English Defence League (EDL) has been a major (if fluctuating) force in recent years, and has produced an intense discourse of national identity. It has also been a social movement of greater breadth than often assumed, as research by the organisation Demos has shown (Bartlett & Littler, 2011). However the EDL's focus has been very strongly on what it has seen as the threat posed by the Islamisation of British culture. It knows what it is against, but has less to say about what it is for.

While these groups and others on the "Far Right" seem to have been primarily concerned to defend their "nation", their articulation of what it is to be British, or English, is, at best, limited. Their nationalisms are ones of negation, rather than being based on real, good experiences of national life. They tend to lack empirical specification

of the nation in question, except when they resort to a simple racism and declare that nation simply to be "white", a declaration that has little claim to be nationalism in any meaningful sense.

Second, in psychoanalytic terms, we can distinguish between the regressively idealised nation and the nation as a much more complex object, of experience as well as of phantasy. The internal nation object can be the centrepiece in a defensive structure, a rallying point for narcissistic rage. Such a nation can be experienced as being possible only in the future or the past. Alternatively, it can be a mixed, but fundamentally good, object, built up in the continuous present through everyday experience of the external nation as a shared culture, shared polity, and material environment. As such, it can, at times, either satisfy or disappoint, and be desired or attacked. Overall, however, it will be a reliable container, and be enjoyed and celebrated.

The declining strength of the nation-state as a source of core identity and societal containment is accompanied by different responses among different sections of the population. Some are, we might say, in denial that anything has been lost, and seek simply to welcome a new postmodern world of cosmopolitan citizenship as a far better home than the restricted space of the modern nation. Some will be resigned to the loss, probably able to find containment elsewhere (see below), but possibly also a little anxious and resentful and willing to cast a vote for a politician who promises to return the lost object. Others, perhaps particularly those with limited cultural capital who are unable to locate themselves in alternative societal identities and containers, will be more active, and will turn to the phantasy nation. Driven by a delusion of pure community, they seek to restore the nation to some mythical condition of wholeness and safety. This involves them in making coercive demands that the container be returned to its previous condition, or to what is imagined it was once like. They are aware that the national container is broken, but are too anxious and angry to be able to think realistically and compassionately about how best to replace it in new and strengthened form.

Shifting modalities of containment

Our large-group identity as a nation has ceased to be compelling, and the state that governs the nation has become a deeply suspect object.

The nation-state is, therefore, a weakened container, so we place less trust in it and look elsewhere for experiences of existential reassurance and anxiety regulation.

To some extent, we have replaced, or partially supplanted, our national identity with identities found at other levels of societal collective and of governance. The imagined community of a county or sub-national region can provide an important source of collective identity, as—increasingly—can the image of a supranational community, as in the case of "European-ness". In the UK in June 2016, after the referendum on whether to leave the EU had resulted in a "Leave" decision, the pained and angry reaction of some of those who had voted "Remain" suggested that they felt they had been wrested away from a body to which they felt a deep and important attachment. While, for some, this attachment is largely symbolic and identity-driven, "Europe" has also, to an extent, become a material provider for some citizens of EU countries.

While positive libidinal investment has drained away from the liberal nation-state, reducing its capacity to offer emotional satisfaction and so to act as a societal container, some commercial corporations have sought to move into the psychic spaces from which the national imago has withdrawn. Here, we see comprehensive programmes of customer care and the engineering of broad emotional attachments to brands, which can offer some containment of consumers' anxieties and also become woven into a sense of lifestyle and social identity. Yet, at the same time, the strongly libidinal zone of the popular has gained in socio-emotional as well as economic and cultural importance, and it is now popular culture which provides the most compelling and effective forms of social identity and emotional containment, for reasons outlined in the preceding chapters: its *raison d'être* as a container, its entwinement with the therapeutic trend, and with the compression together of different psychic spheres.

We find these identities in "fanship" in music and sport, in audience membership, in the "tribes" of consumer culture, and in networks of enthusiasts for all kinds of pursuit. While some of these identifications are relatively superficial, or intermittent, others are not. Commitments to certain musicians or artists, or genres, or to sports teams, or to a sport as a whole, can define persons to themselves, and to others, more deeply than does any idea of national belonging. For example, a UK poll for the BBC (IpsosMORI, 2014) found that people

see their leisure activities as the most important element in their identities—43% cited leisure compared to 20% citing nationality, 7% class, and 6% ethnicity.

The global and personal subject of popular culture

There are two features of these forms of identity that it is relevant to examine here, and they are, to some extent, in tension with each other. First, they are basically transnational, in the sense of being shared across national boundaries, and second, they are intensely personal, in the sense of being typically focused on the subjective experiences of the individual. They look both outwards and inwards. Let us return to two of the major forms of popular culture, as discussed in Chapter One, to consider leading examples of this kind of identity based on global communities of cultural interest.

At one level, football's place in the league of nations often appears to be a troubling one. The aggressive exchanges of coarse insults and the violence that might erupt between fans of competing nations could suggest that football culture is in toxic alliance with regressive forms of nationalism. There are, however, reasons to think that, although on occasions this is the case, in the overall picture we can see how football is supporting the development of more cosmopolitan outlooks. First, the same aggression and violence occurs between fans of rival clubs within one nation, in which context there might be savage hatred expressed towards national team players with a rival club. (This might also even be expressed during an international match.) The Us *vs.* Them distinction for the football "fan" involved in these hostilities is a moveable feast; the nation is not a fixed definer of allegiance or identity. What matters is only that, on any given occasion, there is an enemy. Although international football can act to supply occasional enemies, and in the process some international antipathies could be aroused in wider publics, this occurs outside of any psychological involvement in the actual game of football. Those "supporters" most interested in stand-offs are those attending least to the game on the pitch. At most, international football provides a stage on which nationalist sentiments of all sorts (from the violently racist to the mildly patriotic) can be performed, but this is incidental to the football itself.

Second, alongside the violent elements, and probably in much greater number, there are the fans for whom international football can

be basically educative, on the principle that contact is a powerful anti-dote to prejudice. While travelling to an international football match might not be entirely conducive to immersion in the foreign culture, it does involve elementary contact, and, more importantly, a fan's ordinary interest in the opposition and who they are will enable even the non-travelling supporter to replace a shadowy "other" with actual human beings.

Third, the internationalisation of the leading domestic football leagues has meant that footballers and managers from scores of coun-tries all over the world are now regular performers in stadia and in television coverage of those leagues for their national audiences (not to mention the global availability of coverage of other countries' leagues). Exhaustive media coverage of the premier leagues and their internationally diverse players (boosted by coverage of major interna-tional tournaments) might be the most powerful way in which foot-ball offers to its fans the experience of being part of a huge global community of enthusiasts. This community, and the sense of self that it offers, is based on the aesthetic and social experiences which foot-ball offers. These derive from the disciplines of delight to which all those who participate in, or watch, football subject themselves. Such experiences ultimately transcend nation, and all other geographical or political identities, and have begun to transcend gender.

At the same time, there are strongly personal and interpersonal dimensions to the passion for football. A major commitment of psychic energy to immersion in its aesthetic and technical content is likely to give it a key place in someone's sense of identity, while friend-ship networks intertwined with following or playing it can be one of the most important embodiments of the social self. In various ways, then, football (like other sports) offers membership of a global community, which, like many other collective identities, brings some societal containment to the individual, resting on, but additional to, that provided by enjoyment of the game itself.

The rise of transnational popular music is another major source of globalised identity. The sociologist Regev (2013) has described how what he terms "pop–rock" music illustrates the emergence of a global culture in which national and local styles become materials for inter-national circulation and modification in a complex, unified field of cul-tural production and consumption. This "aesthetic cosmopolitanism" is, he contends, the universal cultural condition of late modernity.

In another book on the development of pop music, Barker and Taylor (2007) highlight the importance in this history of the search for authenticity, and suggest that while cultural authenticity has become less central (contrary to what some theories of the impact of globalisation might predict), personal authenticity in the music has grown in importance.

While the specific contents of popular cultural forms, especially pop–rock music, are sometimes linked with strong political or ideological commitments, the popular culture mode of emotional containment is, in general, non-political, and sometimes anti-political, in its typical lack of interest in the political domain. The rise of popular music culture in the twentieth century, though underpinned by growing affluence and by technological developments in media, was part of the broad trend towards affect, discussed in Chapter Three as the emotionalisation trend or the shift to "therapeutic" culture. This has been both expressive and introspective, and has involved, in particular, a passionate immersion in the experience of romantic love. This phenomenon has a thick margin of sentimentality, and has many internal contradictions: for example, between the space it can create for its listeners to take a reflective stance towards their relationships, and its recycling of more superficial understandings of love. Overall, though, it has been a major enrichment of culture, a still evolving product of a process whereby an increasingly secularised society focused attention on earthly and libidinal concerns, and democratised the sensibilities of intimacy. These are, however, the concerns and sensibilities of the interpersonal and domestic spheres, not those of the economy and polity.

Typically, then, the identities of popular culture arc from the global to the very personal, bypassing the domain of everyday national politics. As has been argued throughout this book, these forms of cultural identity can offer high degrees of containment in their combination of emotional and libidinal expression with restraint and rule-bound social membership. They provide ongoing experiences in which sensual, regressive, and aggressive impulses are reconciled with, and contained by, a tolerant and facilitative, yet also ultimately "other", social authority.

So, if alternative and effective modes of containment like these are available, what is the problem? Why should we not welcome the decline of nationalist fervour, and enjoy and deepen the alternative

forms of containment that are now becoming more accessible to more people? Is it not obviously better, politically, that we cut our obsolete ties to the nation-state and become more global citizens, finding common cause and shared feelings with people across the world who enjoy the same music, or sport, or films as we do? Does it matter that, despite its potential for being an important containing object, the actual status of the nation-state is frequently that of an object of anger, contempt, suspicion, or indifference?

The burden of the argument here is that, yes, it does matter. The problem is that the new modalities of containment detach us from a task at the heart of our societal life, which is the political task of organising society. So, the modality shift has major adverse consequences. It can generate severe problems for democracy, in the "democratic deficit", the alienation of citizens from government, the threat to democracy posed by low turnout, in the psycho-cultural spaces left vulnerable to colonisation by extremist ideologies, and in the general weakening of emotional bonds between people who share the same material environments.

Our commitments to popular culture provide us with an increased range of potential societal containers. They enable us to find more security and fulfilment in the domains of leisure and consumption, and to develop our emotional literacy. However, in helping to usher in the "anti-political age" (as Mulgan, 1994, termed it), they leave an empty space in our relationship to, and contribution to, the work of organising society on which we all depend.

Re-cathecting the liberal–democratic nation-state

This need not have happened; the distribution of affect is not a zero-sum game. The increasing emotional depth of popular culture need not have been gained at the expense of emotional depletion in the political public sphere. But, for the reasons discussed in this chapter (suspicion of the "nation", antipathy towards the state, and an emotionally inauthentic party political culture), the latter development has been contemporaneous with the former. As a result, politics has much to learn from popular culture, and the emotional literacy of the political classes could be much improved through closer attention to the patterns of affect grounded in popular culture. For that, politics needs

to do more than dipping into it (as in much "political marketing") to copy the promotional techniques of consumer culture and the promotional professions. As Street (1997) has argued, politics and popular culture have never been entirely separated spheres of life, as there has always been some political management of culture, and some cultural determination of politics. The tendency towards the compression together of different spheres has greatly increased this interpenetration; the election of Donald Trump is, in part, a reflection of that.

Fundamentally, however, the project of government is different from the projects of entertainment and solace. The recovery of politics needs its reconstitution as an independent and major source of emotional containment and object of emotional investment. Some fundamental reconnections between polity and psyche need to be made. It is not easy to see any means of reconnection other than through experiences of nation. This is not least because most polities are, to a greater or lesser degree, *nation*-states. It is also because the lesson of our study of popular culture is that there is a popular search for societal containment. This comes in various forms, all of which, if they are to achieve some stability of influence, must give expression to the realm of anxiety and desire, and reconcile it with the authority of society. The imagery and discourses of nation can offer this in ways that more administratively defined or anonymised polities cannot, through their address to primitively charged needs for attachment and belonging, their aspirations to security and safety, and their markers of distinctive and sensual collective identity. A recovery of the nation and the nation-state would mean that one of our major large-group identities could align with the political entity of which we are a part, and the embodiment of that entity in the state would be more effective as a modality of containment. One key element in the nationalism thus developed would be a sense of gratitude towards the historical and present nation-state and its people for its protection and provision, whatever else might be felt towards it.

This means that all the difficult questions about what and who might comprise any particular nation need to be answered, in ways that will be acceptable to the majority of that nation's public. An obvious danger is that of slipping into a narcissistic mode of national self-regard that could incubate a more aggressive type of nationalism, or—in the familiar extreme—invite a totalitarian attempt to create a purified

nation. A degree of confidence in the emotional capital already built up in a society would need to be combined with an alertness to the risk that the "nation", as a psycho-political project, could serve a defensive function for some of its citizens.

This conclusion is, politically, not new, amounting as it does to a call for a form of nationalism that is more emotionally charged and identity-based than the blander forms of "civic" nationalism, yet more complex and restrained than most varieties of "ethnic" nationalism. In this final chapter, I have sought to bring a new psychosocial understanding to that political agenda, linked to the book's explorations of popular culture. When assessed psychoanalytically, the powers of contemporary popular culture to bring people together in benign ways can be seen as a demonstration of how regimes of emotional regulation can change, and how new forms of social authority can be delivered to us in ways that offer libidinal satisfactions as well as iterations of societal constraint. This gives some grounds for hope that democratic politics could be reinvigorated by further changes in modalities of societal containment. The development of a benign popular nationalism focused on an image of a de-idealised but everyday "good enough" nation would install a good object—satisfying and containing—at the centre of politics. It would probably be true to say that, currently, many liberal democracies do not have durable good whole objects at the heart of their public spheres, a situation that, by analogy with the mind of the individual, invites both internal breakdown and deep colonisation by the fragmented objects of fundamentalist phantasy.

Notes

1. I will be reporting elsewhere on how the psychoanalytic ideas about nationalism presented here align with the leading theories of nationalism as set out by Anderson (1983), Calhoun (1997), Gellner (1983), Greenfeld (2016), Kedourie (1993), Kohn (1944), Kristeva (1993), Miller (1995, 2000), Poole (1999), and, particularly, Smith (1979, 1986, 1991, 2003), as well as with feminist literature on nationalism, for example, Anthias & Yuval-Davis (1991), Enloe (1990), and Nagel (2010).

2. This term still usefully points to a cluster of political positions, even though the idea of a Right–Left dimension is no longer helpful in describing the major differences across the whole field of ideology and policy.

REFERENCES

Anderson, B. (1983). *Imagined Communities. Reflections on the Origin and Spread of Nationalism*. London: Verso.

Anderson, D., & Mullen, P. (1998). *Faking It: The Sentimentalisation of Modern Society*. London: Social Affairs Unit.

Anthias, F., & Yuval-Davis, N. (1991). *Racial Boundaries: Race, Nation, Gender, Colour and Class and the Anti-Racist Struggle*. London: Routledge.

Atkinson, S., Marshall, B., & Mortimore, R. (2012). *Britain 2012: Who Do We Think We Are?* London: IpsosMORI.

Barker, H., & Taylor, Y. (2007). *Faking It: The Quest for Authenticity in Popular Music*. London: Faber and Faber.

Bartlett, J., & Littler, M. (2011). *Inside the EDL: Populist Politics in a Digital Age*. London: Demos.

Beck, U., & Beck-Gernsheim, E. (1995). *The Normal Chaos of Love*. Oxford: Polity Press.

Benjamin, J. (1988). *The Bonds of Love: Psychoanalysis, Feminism and the Problem of Domination*. New York: Pantheon Books.

Bertilsson, M. (1985). Love's labours lost. In: M. Featherstone, M. Hepworth, & B. S. Turner (Eds.), *The Body, Social Process and Cultural Theory* (pp. 297–324). London: Sage.

Bion, W. R. (1962). *Learning from Experience*. London: Heinemann.

93

Brown, J. (2000). What is a psychoanalytic sociology of emotion? *Psychoanalytic Studies*, 2(1): 35–49.

Calhoun, C. (1997). *Nationalism*. Buckingham: Open University Press.

Campbell, C. (1987). *The Romantic Ethic and the Spirit of Modern Consumerism*. Oxford: Blackwell.

Craib, I. (1994). *The Importance of Disappointment*. London: Routledge.

Denzin, N. (1989). *The Research Act*. Upper Saddle River, NJ: Prentice Hall.

Derrida, J. (1972). *Writing and Difference*. Chicago, IL: University of Chicago Press.

Elias, N. (1978). *The Civilising Process. Vol. 1. The History of Manners*. Oxford: Blackwell.

Elias, N. (1982). *The Civilising Process. Vol. 2. State Formation and Civilisation*. Oxford: Blackwell.

Elias, N. (1996). *The Germans*. Cambridge: Polity Press.

Elias, N., & Dunning, E. (1986). *Quest for Excitement: Sport and Leisure in the Civilising Process*. Oxford: Blackwell.

Enloe, C. (1990). *Bananas, Beaches and Bases: Making Feminist Sense of International Politics*. Berkeley, CA: University of California Press.

Erikson, E. (1959). *Identity and the Life Cycle*. New York: International Universities Press.

Fairbairn, W. R. D. (1943). The repression and return of bad objects (with special reference to the "war neurosis"). In: *Psychoanalytic Studies of the Personality* (pp. 59–81). London: Routledge and Kegan Paul, 1952.

Figlio, K. (1998). Historical imagination/psychoanalytic imagination. *History Workshop Journal*, 45: 199–221.

Foucault, M. (1990/1976). *The History of Sexuality: An Introduction*. London: Penguin.

Freud, S. (1911b). Formulations on the two principles of mental functioning. *S. E.*, 12: 213–226. London: Hogarth.

Freud, S. (1916a). On transience. *S. E.*, 14: 305–307. London: Hogarth.

Freud, S. (1917e). Mourning and melancholia. *S. E.*, 14: 243–258. London: Hogarth.

Freud, S. (1930a). *Civilization and its Discontents*. *S. E.*, 21: 61–145. London: Hogarth.

Freud, S. (1933b). Why war? *S. E.*, 22: 199–215. London: Hogarth.

Fromm, E. (1976). *To Have Or To Be?* New York: Harper Collins.

Frosh, S. (1991). *Identity Crisis: Modernity, Psychoanalysis and the Self*. London: Macmillan.

Furedi, F. (2003). *Therapy Culture. Cultivating Vulnerability in an Uncertain Age*. London: Routledge.

Gay, P. (1986). *The Tender Passion*. Oxford: Oxford University Press.

Gellner, E. (1983). *Nations and Nationalism*. Ithaca, NY: Cornell University Press.

Gerth, H., & Mills, C. W. (Eds.) (1970). *From Max Weber: Essays in Sociology*. London: Routledge.

Giddens, A. (1992). *The Transformation of Intimacy*. Cambridge: Polity Press.

Goleman, D. (1996). *Emotional Intelligence: Why It Can Matter More Than IQ*. London: Bloomsbury.

Greenfeld, L. (2016). *Advanced Introduction to Nationalism*. Cheltenham: Edward Elgar.

Harrison, B. (1971). *Drink and the Victorians*. London: Faber and Faber.

Harvey, D. (1990). *The Condition of Postmodernity. An Enquiry into the Origins of Cultural Change*. Oxford: Blackwell.

Hinshelwood, R. D. (1987). *What Happens in Groups. Psychoanalysis, the Individual and the Community*. London: Free Association Books.

Hinshelwood, R. D. (1989). *A Dictionary of Kleinian Thought*. London: Free Association Books.

Hochschild, A. (1983). *The Managed Heart: The Commercialisation of Human Feeling*. Berkeley, CA: University of California Press.

Hoggett, P. (1989). 'A labour of love' and 'A primary social medium': two problematics in contemporary psychoanalysis. *Free Associations*, 15: 87–107.

IpsosMORI (2014). UK becoming "more local and global". www.ipsos-mori.com/researchpublications/researcharchive/3365/UK-becoming-more-local-and-global.aspx (accessed 31 July 2016).

Jaques, E. (1955). Social systems as a defence against persecutory and depressive anxiety: a contribution to the psychoanalytic study of social processes. In: M. Klein, P. Heimann, & R. Money-Kyrle (Eds.), *New Directions in Psychoanalysis* (pp. 478–498). London: Tavistock.

Kedourie, E. (1993). *Nationalism* (4th edn). Oxford: Blackwell.

Kellner, P. (2012). *Democracy on Trial. What Voters Really Think of Parliament and our Politicians*. London: YouGov. http://cdn.yougov.com/cumulus_uploads/document/ww4o7wko1q/WebVersion_Democracy%20in%20Britain%20A5.pdf (accessed 31 July 2016).

Klein, M. (1935). A contribution to the psychogenesis of manic-depressive states. *International Journal of Psychoanalysis*, 16: 145–174.

Kohn, H. (1944). *The Idea of Nationalism. A Study of its Origins and Background*. London: Macmillan.

Kristeva, J. (1993). *Nations Without Nationalism*. New York: Columbia University Press.

Lasch, C. (1979). *The Culture of Narcissism*: *American Life in an Age of Diminishing Expectations*. New York: Norton.

Lasch, C. (1984). *The Minimal Self: Psychic Survival in Troubled Times*. New York: Norton.

Lyotard, J.-F. (1984). *The Postmodern Condition: A Report on Knowledge*. Manchester: Manchester University Press.

Marcuse, H. (1955). *Eros and Civilisation*. London: Abacus Books, 1972.

Meltzer, D. (1968). *Sexual States of Mind*. Strathtay: Clunie Press.

Menzies Lyth, I. (1959). The functioning of social systems as a defence against anxiety. In: *Containing Anxieties in Institutions: Selected Essays, Vol. 1* (pp. 43–85). London: Free Association Books.

Miller, D. (1995). *On Nationality*. Oxford: Clarendon Press.

Miller, D. (2000). *Citizenship and National Identity*. Cambridge: Cambridge University Press.

Mulgan, G. (1994). *Politics in an Anti-Political Age*. Cambridge: Polity Press.

Nagel, J. (2010). Masculinity and nationalism: gender and sexuality in the making of nations. *Ethnic and Racial Studies, 21*(2): 242–269.

Ogden, T. (2004). On holding and containing: being and dreaming. *International Journal of Psychoanalysis, 85*: 1349–1364.

Parsons, T. (1951). *The Social System*. Glencoe, NJ: Free Press.

Phillips, A. (1995). *Terrors and Experts*. London: Faber and Faber.

Poole, R. (1999). *Nation and Identity*. London: Routledge.

Regev, M. (2013). *Pop–Rock Music. Aesthetic Cosmopolitanism in Late Modernity*. Cambridge: Polity Press.

Richards, B. (1989). *Crises of The Self*. London: Free Association Books.

Richards, B. (2007). *Emotional Governance. Politics, Media and Terror*. Basingstoke: Palgrave.

Richards, B. (2014). "Abide with me." Mediatised football and collectivised mourning. In: C. Bainbridge & C. Yates (Eds.), *Media and the Inner World: Psycho-cultural Approaches to Emotion, Media and Popular Culture* (pp. 19–33). Basingstoke: Palgrave.

Richards, B., MacRury, I., & Botterill, J. (2000). *The Dynamics of Advertising*. Reading: Harwood.

Rieff, P. (1987). *The Triumph of the Therapeutic*. Chicago, IL: University of Chicago Press.

Rose, N. (1990). *Governing The Soul: The Shaping of the Private Self*. London: Routledge.

Rustin, M., & Rustin, M. (1987). *Narratives of Love and Loss*. London: Verso.

Salovey, P., & Sluyter, D. (Eds.) (1997). *Emotional Development and Emotional Intelligence: Educational Implications*. New York: Basic Books.

Scruton, R. (1999). The first person plural. In: R. Beiner (Ed.), *Theorising Nationalism* (pp. 279–293). Albany, NY: State University of New York Press.

Searles, H. (1960). *The Nonhuman Environment in Normal Development and in Schizophrenia*. New York: International Universities Press.

Seidler, V. J. (1998). Masculinity, violence and emotional life. In: G. Bendelow & S. J. Williams (Eds.), *Emotions in Social Life: Critical Themes and Contemporary Issues* (pp. 193–210). London: Routledge.

Sennett, R. (1977/1993). *The Fall of Public Man*. London: Faber and Faber.

Smith, A. (1979). *Nationalism in the Twentieth Century*. Oxford: Martin Robertson.

Smith, A. (1986). *The Ethnic Origins of Nations*. Oxford: Blackwell.

Smith, A. (1991). *National Identity*. Harmondsworth: Penguin.

Smith, A. (2003). *Chosen Peoples: Sacred Sources of National Identity*. Oxford: Oxford University Press.

Smith, D. (2006). *Globalization: The Hidden Agenda*. Cambridge: Polity Press.

Stern, D. (1985). *The Interpersonal World of the Infant*. New York: Basic Books.

Street, J. (1997). *Politics and Popular Culture*. Philadelphia: Temple University Press.

Symington, J., & Symington, N. (1996). *The Clinical Thinking of Wilfred Bion*. London: Routledge.

Thompson, E. P. (1967). Time, work discipline, and industrial capitalism. *Past and Present*, 38: 56–97.

Usher, R. (1997). Telling a story about research and research as story-telling: postmodern approaches to social research. In: G. McKenzie, J. Powell, & R. Usher (Eds.), *Understanding Social Research: Perspectives on Methods and Practice* (pp. 27–41). London: Routledge.

Volkan, V. (2004). *Blind Trust. Large Groups and their Leaders in Times of Crisis and Terror*. Charlottesville, VA: Pitchstone.

Volkan, V. (2013). *Enemies on the Couch*. Durham, NC: Pitchstone.

Weatherill, R. (1997). Smooth operators. In: D. Kennard & N. Small (Eds.), *Living Together* (pp. 50–66). London: Quartet Books.

Wernick, A. (1991). *Promotional Culture*. London: Sage.

Williams, S. J., & Bendelow, G. (1998). Introduction: emotions in social life: mapping the sociological terrain. In: G. Bendelow & S. J. Williams (Eds.), *Emotions in Social Life: Critical Themes and Contemporary Issues* (pp. xv–xxx). London: Routledge.

Winnicott, D. W. (1960). The theory of the parent–infant relationship. *International Journal of Psychoanalysis*, 41: 585–595.

Winnicott, D. W. (1965). *The Maturational Processes and the Facilitating Environment*. London: Hogarth.

Woodward, K. (1997). *Identity and Difference: Culture, Media and Identities*. London: Sage.

Yates, C. (2000). Masculinity and good enough jealousy. *Psychoanalytic Studies*, 2(1): 77–88.

Zeldin, T. (1994). *An Intimate History of Humanity*. London: Minerva.

INDEX

goods, 42–43
hedonism, 59
markets, 62
provisioning, 62
societies, xxii, 6–7, 39, 42
countryside, 4, 7, 26, 71
Craib, I., 34, 47

delusion, 85
apocalyptic, 25
moment, 25
Denzin, N., 38
Derrida, J., 38
development(al), xiii, xix, xxii, 15, 38,
40, 65, 68, 74, 80–81
of consumer society, 39, 42
early, xviii, 15
emotional, xvii, 5, 39
functions, 2
journey, 5
identity, 45
mental, 65
mixed, xii, 43
polyvalent, 32
positive, xii, 42
psychological, 2
relationship, 33
role, 2
self-, 5
sinister, 43
of therapeutic culture, 32, 39, 43–44
direct action, 17, 22–26
Dunning, E., 8

ego, xxv, 31–32 see also: object
auxiliary, 8
pleasure, 34
reality, 34–36, 58
super-, xii, xxiv–xxv, 32
protective, 24
Elias, N., xxi, 7–8, 33, 41–42, 69, 78
emotional(ly) (passim) see also:
conscious, development,
regulation, self, subject,
unconscious

attachment, 86
autonomy, 45
bonds, 90
capital, xxiii, 3, 77, 92
commitment, 36
communication, 47
containment, xii, xvi, 2, 66, 80–81,
83, 86, 89
damage, 52
depletion, 90
depth, 45, 90
deregulation, 41
dimension, 35–36, 56
diverse experiences, xxiv
dynamics, 5, 50
effort, xviii
engagement, 39
expression, xxi–xxii, 38, 89
expressivity, xxii, 32–34, 48–49
governance, xxiii–xxiv, 63, 81
inauthenticity, 81
inhibition, 35
intelligence, 34
investment, 4, 82, 91
labour, 36–37, 45
learning, 40
life, xii, 35, 39–40, 43, 47, 50, 56–57,
69
literacy, 34, 90
management, 54, 56, 61
maturity, 80
meanings, xvi, xx
mechanism, 28
narratives, 57, 60
needs, xvi, 51
public sphere, xxv, 82
reactions, 69
reality, 22, 68, 81
relationships, x
release, 34–35
reserve, 35
resources, 3, 84
responses, 42
satisfaction, 86
specialists, 45